AAH

ASSOCIATION OF ART HISTORIANS

Careers in Art History

Fourth Edition

ISBN 978-0-9571477-2-0

Published in 2013 by The Association of Art Historians (AAH)
70 Cowcross Street
London EC1M 6EJ
www.aah.org.uk

Registered Charity No. 282579

Edited by: Matthew Klise, Rosalind McKever, Elizabeth Moore
Copy editing, design, and layout: Jannet King edbulletin@aah.org.uk
Cover design: Cavendish Design & Advertising

Contents

Contents *continued*

Introduction

Rosalind McKever

Former Chair, AAH Student Members Group
Editor, *Careers in Art History*

For a young academic discipline, the range of career possibilities open to Art History graduates can be surprising; knowledge about art and other skills developed through an Art History degree can be applied to a range of vocations, both within and beyond the visual arts.

When embarking on the competitive arts job market it pays to be well-informed. This book aims to guide you through the options available – whether you are a prospective undergraduate student of Art History wondering where the degree could take you, or a professional looking to develop your existing art history career or move into the field.

In this new edition we have grouped jobs by theme to show the range of careers available within certain sectors and how they interconnect. We have also included more potential careers, including less obvious roles such as advertising, heritage tourism and museum retail, and reflected the changing job market with an extended entry on freelance work. There are also new sections with practical information on marketing yourself, writing CVs and finding funding. The further information sections accompanying each entry have also been updated.

We, of course, welcome your feedback and suggestions of new entries for the next edition. Please contact us on students@aah.org.uk

As well as producing this publication, the AAH Student Members Group supports the career development of Art History students by running two annual careers days, aimed at those with, or pursuing, undergraduate or postgraduate qualifications, at which arts professionals from a range of fields speak about their careers and give practical guidance. The group also gives research students a forum through which to disseminate their work by running two academic symposiums during the year and a dedicated student session at the AAH Annual Conference. The AAH Internship Awards give financial support to students undertaking valuable volunteering opportunities to develop their career and, as is evident throughout this book, volunteering is often a necessary stage in the development of a career in the arts.

This publication was made possible by a large team of people. My sincerest thanks go to each of the authors who have generously given their time to explain their jobs, and how their Art History degrees shaped their careers. I would also like to thank the team of people involved in putting this publication together. Elizabeth Moore and Matthew Klise from the AAH Student Members Committee helped research and contact the authors. Jannet King tied together the whole project, copy-edited the text and laid out the design. The AAH office staff, particularly Pontus Rosén (Chief Executive) and Matt Lodder (Finance and Policy Manager), have also offered invaluable support throughout the process of creating this new extended edition. My thanks must also go to Sophie Bostock and Graeme Smart, editors of the two previous editions of this publication, who built it up into such a useful guide.

On behalf of everyone involved, I hope that you find this guide inspiring and wish you the best of luck with your career in art history!

Arts Administrator

Kirstie Gregory

Research Programme Assistant, Henry Moore Institute

The wide scope of duties covered by the term 'arts administrator' provides an opportunity to develop expertise in the processes and procedures behind the smooth running of artistic programmes. A solid grounding in the fundamentals of an organisation can later be applied to complementary areas of work. Any professional role will involve administration to a greater or lesser degree, and the opportunity to develop organisational and communication skills, efficiency, and resourcefulness, will be highly valued by future employers.

In arts administration the size of the organisation can be key in determining the scope of the role. The smaller organisation will suit those who enjoy helping out and developing a diverse range of roles. The larger arts institutions will be a better match for those who wish to develop more specific administrative skills.

What the job involves

Arts administration can involve many different tasks and skills, depending on the overall purpose and vision of the wider organisation. For those with an interest in the maintenance of often architecturally complex buildings, arts administration can be akin to facilities management, including liaison with technical and curatorial staff, involvement in the smooth maintenance and running of the structure and infrastructure of an organisation, understanding local council regulations, evaluating software systems, and comprehending the skills and number of staff required to keep a building operational. Alongside all this, the ability to work with, predict or manage budgets, process invoices, and adhere to and improve financial policies will be highly desirable.

Art History graduates more interested in communication can also find arts administration a rewarding avenue. The role might include tasks such as developing and distributing copy (calls for papers, conference outlines, publicity materials, web texts), liaising with visitors over travel requirements, working in partnership with other arts organisations, responding to public enquiries, and comprehending and communicating institutional policy in areas such as copyright, strategy, vision, and organisational history. Any administrative role will in all likelihood include skills one can pick up easily through prior work experience, such as dealing efficiently with post and email correspondence, and developing and maintaining filing and database systems.

Useful skills

The more outward-facing nature of this role can include organising public or academic events, co-ordination of institutional participation in external events, and representing your organisation at both. A willingness to share responsibility for any public-speaking commitments will impress, demonstrating a collegiate spirit and building up your experience in this area. Both an in-depth understanding of institutional history, and breadth of knowledge of the day-to-day minutiae can prove invaluable during public events. Should you be quizzed regarding policy or company vision or, alternatively, need to find the correct key for the fuse box, common sense and composure will be noted and appreciated.

Confidence and willingness to acquire the required skills will be beneficial for a candidate for an administrative position. For example the demonstration of impressive competency with AV equipment, knowledge of copyright law, or fluency in a second language could give you an edge both at interview and when in post – an opportunity to exceed expectations. Arts organisations and universities often have publications programmes which, depending on the size of the organisation, may be an additional area that weaves into arts administration. There does not seem to be such a thing as too many pairs of eyes copy-editing a document, and for those who enjoy attention to detail I would imagine that offers of help in this area would be appreciated and, again, could lead to a more specialised career in this area.

Qualifications

There are no postgraduate qualifications necessary for this role, and, if combined with an Art History BA, the most useful work experience may well be professional administrative skills picked up from any complementary sector. If a graduate wished to complete further study before seeking employment, a Museum Studies qualification or Arts Management course would be an excellent way of gaining further insight into the internal structure of museums and galleries.

FURTHER INFORMATION

IdeasTap
www.ideastap.com
An arts charity set up to help young, creative people at the start of their careers.

Arts Hub
www.artshub.co.uk/uk/arts-jobs
Jobs and news information for professionals working in the UK arts and cultural industries.

Arts Jobs
www.artsjobs.org.uk
The Arts Council's free mailing list service.

University of the Arts, London Creative Careers
www.arts.ac.uk/careers

Investigate if the geographical areas you wish to work in have arts networks (and therefore probably email circulation lists) you can subscribe to. Administrative jobs may very likely be advertised on a local level before or as well as on a national level. For example, Leeds Visual Arts Forum www.lvaf.org.uk

Auctioneer

Rupert Toovey FRICS

Senior Partner, Toovey's Auctioneers

Auction houses combine commercial and academic expertise to identify, market and sell fine art, antiques and collectables. Whether you are selling dinosaur eggs or a work by Damien Hirst there will be an auction house with a specialist for you.

Auction houses these days are central to the fine art, antiques and collectables market, selling objects worth some billions of dollars worldwide annually. The breadth of technical and operational knowledge required, especially with regard to the law, in what is a global market, is considerable. There are plenty of employment opportunities in both international salerooms and provincial auction houses. For those wishing to catalogue, value and sell there are two main paths.

As a generalist, your knowledge will need to be broad, but sound, across all the major disciplines, including paintings and prints, furniture, silver, English and European ceramics and glass, Oriental ceramics and works of art, clocks, watches and barometers, and collectors items. It may also be necessary to refer clients to specialists when appropriate. As a specialist, you will concentrate on one small area of expertise (e.g. contemporary art or 18th-century English furniture). Both offer opportunities in full-time employment or as a part-time consultant.

A varied day can involve meeting clients at the client's home or at the saleroom in order to value objects for sale, probate (e.g. inheritance tax) or insurance. Other days will be spent on research and reports. And, of course, there is the theatre and excitement of the auction sales. Auctions are a deadline industry where catalogues must be printed and posted to potential buyers in good time. This sometimes requires putting in extra hours.

FURTHER INFO *see after next entry*

Salaries within the profession are modest to begin with, and it may take considerable time to acquire the working and practical knowledge usually necessary for promotion and greater pay. Salaries are generally comparable with those of museum professionals. Usually, the more senior the post the better the remuneration.

Qualifications

The majority of auction houses, especially international operations, will be looking to hire graduates with an Art History degree or related background. Qualifications matter much more than in the past, and this trend will continue as global business increases. The only internationally recognised professional qualification is that of the Royal Institution of Chartered Surveyors (RICS), which has a specialist Arts and Antiques Faculty. This qualification is highly regarded by the profession, other professions and clients. Its standing among the professions, and the code of practice which sets its members apart from the unregulated sector, give clients the assurance they need that they are in good hands.

Qualified RICS professionals will often work very closely with lawyers, bankers, accountants, insurers, loss adjusters and other professionals in the course of their business lives.

Public awareness of the auction world, fine art, antiques and collectables has opened up media and other public opportunities for some auctioneers and valuers (e.g. on television and radio, speaking to collectors' societies).

Many dealers start their working lives in auction houses, whilst others move into insurance, conservation or restoration, or become directors or curators in museums. They develop their skills and broaden their knowledge in the saleroom, learn about the world of business, and develop a network of contacts who share their love for, and enjoyment of, the things that fascinate them.

Subject Specialist

Tom Best

Junior Specialist, Impressionist and Modern Art, Christie's, London

Most specialists in auction houses started their career as a cataloguer, which enabled them to build and develop a foundation of expertise.

A cataloguer is responsible for writing the description of a work for the auction sale catalogue. This involves everything from recording the basic measurements of a work and its medium, to in-depth research of the work's provenance, exhibition history, and literature references. This research is key to helping reinforce a work's authenticity and, in some cases, can lead to the need for verification from an external expert. This hands-on personal experience with the art work gives one an opportunity to gain a thorough understanding of a field, and builds a specialist knowledge of the works of individual artists.

The role of cataloguer will hopefully develop to that of a junior specialist and then, over years, to associate specialist, senior specialist, and possibly later to that of Head of Sale in a specific field of art.

A subject specialist's time is spent valuing works and securing the consignment of works for the next sale. Valuations are conducted for many reasons, including tax, insurance, auction estimates, and private sales estimates. A lot of these are done *in situ*, which therefore involves much travelling.

A Head of Sale works with an international team, coordinating the works for the next auction. He or she is responsible for meeting budgets, creating the catalogue, curating the presale exhibitions, and, ultimately, for generating enthusiasm among potential buyers.

There are many plus sides to a career as a specialist, whether it is of Old Master Paintings, Impressionist and Modern Art, Post War and Contemporary Art, Antiquities, or one of the many other departments, not least spending at least five days a week – often more – immersed in your chosen field. For a renowned global company such as Christie's, built on expertise, integrity, and unparalleled service, working with clients and building international relationships both internally with colleagues and externally with clients is key. More often than not, the research, valuing, and selling of a collection becomes an exercise in inter-departmental collaboration, as clients' collections often require many different areas of expertise. It is a demanding and challenging role which is both inspiring and rewarding.

Qualifications

The qualification generally required to get in on the bottom rung of the career ladder is at least a BA in Art History or Decorative Arts – with an MA an advantage. Fluency in a foreign language is highly regarded.

Getting as much work experience as possible in a related field is strongly advised – not only to enhance your employment prospects, but to help you get a feel for which field you wish to specialise in. All the while, it is good to keep an eye on the current affairs of the art world, perhaps through subscribing to daily newsletters such as www.artdaily.org

FURTHER INFORMATION *see overleaf*

FURTHER INFORMATION

Job advertisements
Antiques Trade Gazette
www.antiquestradegazette.com/jobscourses

Drummond Read Recruitment and Training
t: 020 3418 0194
e: info@drummondreadrecruitment.com
w: www.drummondreadrecruitment.com

Courses
Arts & Antiques Assessment of Professional Competence
(APC)
Royal Institution of Chartered Surveyors (RICS), RICS
Contact Centre, Surveyor Court, Westwood Way,
Coventry CV4 8JE
t: 0870 333 1600
e: contactrics@rics.org
w: www.rics.org

MA in Arts Market Appraisal (Professional Practice)
Kingston University, Faculty of Art, Design & Architecture,
Kingston University, Knights Park, Kingston, Surrey
KT1 2QJ
t: 020 8547 8062
e: designpostgrad@kingston.ac.uk
w: www.kingston.ac.uk

The Christies Art Business Course
www.christieseducation.com/london_artbus.html

Publications
Art Daily
www.artdaily.org

Antiques Trade Gazette
www.antiquestradegazette.com
Gives information about UK auction houses

Conservation: An Overview

Alison Richmond

The Institute of Conservation (ICON)

Updated by Susan Bradshaw

Conservation is concerned with the care and preservation of a huge range of works of artistic and historical importance. Conservation involves the understanding of materials and technology as well as the historical and social significance of these works. All works of art and artefacts are deteriorating, some more quickly than others. The first duty of the conservator is to slow down the rate of deterioration either by manipulating its environment (preventive conservation) or by intervening in the object itself. Conservators treat objects, physically and chemically, in order to preserve them. It is sometimes necessary to restore them to a presumed previous state in order to facilitate understanding. The work of conservators enables us to understand and enjoy our patrimony while at the same time ensuring that it will be preserved for future generations. Conservators work in the public interest and their activities are therefore governed by codes of ethics.

The profession

The conservation profession has evolved into two main groups: one for moveable cultural property (e.g. museum collections), and another for built heritage. Currently there are moves within the profession to bring these groups together. Conservation professionals can be found in museums, in large heritage organisations, such as English Heritage and The National Trust, and in private businesses ranging in size from single individuals to as many as 30 to 40 personnel. While 20 years ago museum conservators were mainly to be found 'at the bench' in studios, workshops and laboratories, nowadays conservators take their place alongside other museum colleagues in teams that plan, prepare and execute gallery installations and temporary exhibitions, educational programmes and public events.

Many conservators who are trained to work on objects find themselves more and more often dealing with people and resources. Some leave the studio altogether and dedicate themselves to management. Other conservators spend most of their time dealing with preventive conservation programmes. Still others have moved from practical conservation to conservation education. Another group of conservation professionals, conservation scientists, are qualified chemists or physicists who study and advise on the materials and deterioration of art and artefacts. Conservators working in private practices may do much of their work for the art market; however, they may also tender for work that museums and other heritage groups are contracting out. In this way the interface between the public and private sectors is becoming more fluid.

The knowledge base of the profession is continually being developed. Conservation research ranges from publishing observations made during treatments to taking part in international research projects, such as those funded by the European Commission.

Specialist disciplines

Conservation (and conservation education) is generally divided into areas of specialisation. These vary across institutions and educational programmes. There are institutions that view themselves as dealing, in the main, with archaeological artefacts (e.g. The British Museum), or ethnographical (e.g. The Horniman Museum), while others are dedicated to the fine arts (e.g. The National Gallery) and decorative arts (e.g. Victoria and Albert Museum). Within these are further divisions of materials or types of object. Some of the main ones are: organic/inorganic, paper, books, paintings, textiles, furniture, and metalwork. In smaller museums or businesses, where there may be only one conservator, it may be necessary to work across a range of materials or object types.

Conservation education

It is still possible to gain conservation expertise through a period of apprenticeship, and this is the case with some

of the building crafts, such as the conservation of stonework. However, a course in higher education is now the preferred route. There is a small number of BA programmes, but the generally accepted qualification for entering employment is fast becoming an MA. A small number of courses also offer research degrees, MPhil or PhD.

Courses usually have both an academic and a practical element. They tend to be vocational, in that they prepare the student to enter the workforce as a practical conservator. Entry requirements vary enormously and it is difficult to generalise; each discipline usually has particular skill requirements, such as metalworking or woodworking skills. Among the possible prerequisites for entry to MA courses are:

♦ a BA in a relevant subject, such as Conservation, Art History, Archaeology, Fine Art/Craft, Physics/Chemistry

♦ art/craft skills

♦ Chemistry/Physics A level

♦ understanding and experience of conservation gained through a BA or work experience.

These are just some of the possible prerequisites. The field of conservation is enriched by the fact that conservators come from many different backgrounds and conservation is a second career for many.

Professional accreditation

PACR (Professional Accreditation of Conservator-Restorers) is based on a set of professional standards and owned by Icon, the Institute of Conservation. It is operated by Icon in association with the British Horological Institute and the Archives & Records Association (UK & Ireland). Conservator-Restorers accredited by PACR (ACR) have demonstrated to assessors that they have the appropriate knowledge, practical skills and sound professional judgement.

Work experience

Work experience in conservation is a thorny issue. On the one hand, it is strongly recommended before applying for a higher degree, while on the other, it is very difficult to get experience if you are not registered on a course or do not already have a qualification. In addition, work experience in the form of an internship is now considered by the profession to be an essential part of the formative process. Work experience ranges from informal and irregular periods of volunteer work to well-defined internships that can last as long as a year. The tasks will also vary enormously. Nevertheless, people do still manage to get experience working in conservation departments and businesses.

Getting a job

The museum market currently takes the form of a mixed economy of permanent and short-term contract posts to enable museums to deal with the continually changing demands of large projects. Many conservators today have to be prepared to move from one job to the next every few years. The private sector is equally flexible, with many businesses hiring staff to deal with projects requiring specific skills. Jobs in national museums are generally advertised in the national press. It is also worth looking on the websites of the professional bodies (see Further Information overleaf) and in the conservation publications that carry classified advertising.

Finally, a brief word about pay. A museum employee's pay is determined by the rules governing public-sector spending. Research has shown that museum employees are less well paid than their counterparts in the private sector, and that increases in salaries over the past 30 years have only just exceeded inflation, although the baseline for employees starting out on their careers has risen considerably over the last decade or so.

Nevertheless, it is probably fair to say that most conservators feel that the benefits of having direct involvement with real artefacts and works of art outweigh many of the disadvantages.

FURTHER INFORMATION *see also after specialist entries*

Organisations

The Institute of Conservation (Icon)
Unit1.5 Lafone House,
The Leathermarket, Weston Street, London SE1 3ER
t: 020 3142 6785
e: membership@icon.org.uk
w: www.icon.org.uk
Icon is the principal professional body for conservators of various specialisms in the UK, and a lead voice for conservation lobbying in all areas. It is also responsible for the management of professional accreditation. The Training Directory, a guide to conservation programmes in the UK, is available on the Icon website. See also the page on their website headed: Development Route Map for Conservators

International Council of Museums Committee for Conservation (ICOM-CC)
www.icom-cc.org
Holds triennial conferences and produces publications.

International Centre for the Study of the Preservation and Restoration of Cultural Property (ICCROM)
www.iccrom.org
Runs short courses and produces a training directory that lists conservation courses around the world.

The International Institute for Conservation of Historic and Artistic Works (IIC)
3 Birdcage Walk, London, SW1H 9JJ
t: 020 7799 5500
e: iic@iiconservation.org
w: www.iiconservation.org
Established for over 50 years, and a major international body for practising conservators. Many conservators in the UK maintain both IIC and Icon membership. The IIC holds biennial conferences and produces publications.

The Getty Conservation Institute (GCI)
1200 Getty Center Drive, Suite 700, Los Angeles, CA 90049-1684
t: (310) 440 7325
e: gciweb@getty.edu
w: www.getty.edu/conservation
An outstanding resource for conservation education and research.

Conservation Online (CoOL)
A database of conservation information.
w: palimpsest.stanford.edu

Courses

Career Planning/Development Route Map for Conservators.
Interactive website on www.icon.org.uk to help you work out what qualifications are needed.

Professional Accreditation of Conservator-Restorers (PACR)
w: www.icon.org.uk

Internships

Available with Icon www.icon.org.uk

Books

Chris Caple, *Conservation Skills: Judgement, Method, and Decision-Making*, London: Routledge, 2000.

Nicholas Stanley Price, et al., *Historical and Philosophical Issues in the Conservation of Cultural Heritage*, Los Angeles: J. Paul Getty Trust, 1996.

Elizabeth Pye, *Caring for the Past: Issues in Conservation for Archaeology and Museums*, London: James & James, 2000.

Conservator: Ceramics & Glass

Juanita Navarro ACR, FRIC

Freelance Conservator, Ceramics, Glass and Enamels

Ceramics and glass conservation and restoration generally refers to fine decorative ceramic and vessel glass, antiques and collectables. The specialisation also includes: archaeological material and antiquities, stained glass (windows and art works), ceramic sculptures, architectural schemes including terracotta, tiles, chandeliers and mirrors, cold-painted ceramics (rather than glazed through firing) and enamels on metal. In addition, ceramics and glass are often found as components of furniture, textiles, metals, and together with other materials.

Conservation includes all activities directed at ensuring the survival and preservation of the objects. Restoration implies work not essential to the survival of the object. Both aspects of the work are based on ethical decisions and procedures using reversible treatments and materials whenever possible.

People arrive at conservation from a variety of backgrounds, often artistic, but also academic and business. These days there is much more to conservation than bench work. Nevertheless, the hands-on practising conservator needs patience and an eye for detail, good colour vision, manual dexterity and an ability to plan and carry out complex and delicate procedures. Conservation science is an intrinsic part of all conservation, including the areas of preservation and prevention. All conservation work should be fully documented; good writing skills are therefore essential.

Ceramics and glass conservators work for the private sector (antiques dealers, private individuals) or the public sector (museums, The National Trust, etc). The work often requires the reconstruction of a broken object by bonding, using a variety of materials to fill gaps, modelling missing parts, and retouching the fills with cold paints. However, conservators are also required to renew deteriorated previous restorations: some adhesives eventually lose their strength and cannot hold the weight of the object; the materials used to fill gaps in glass become yellowed and unsightly; paint materials used to retouch fills in ceramics eventually discolour so badly that they become aesthetically distracting.

There are other interesting aspects for conservators to explore. Examples include research carried out by conservation scientists, such as testing the ageing characteristics of conservation materials, interdisciplinary projects between conservators, chemists and materials scientists, and collections management.

Large museums have conservation departments where conservators are able to specialise in one discipline, such as ceramics and glass. Small museums may employ a conservator with a multidisciplinary knowledge base or send work out to private conservators. Positions in museums are few, although courses may include a placement in a museum as part of the course. Other alternatives for conservators are to find employment in an established private workshop or to set up a workshop on their own or in partnership with colleagues.

Courses vary in length, sometimes according to previous experience. Two or three years of full-time study is usual. Course descriptions have clear outlines of their content and emphasis, whether academic or practical, specialised or multidisciplinary; it is up to the prospective students to be clear about their own needs.

FURTHER INFORMATION

Courses

West Dean – The Edward James Foundation
West Dean, Chichester, West Sussex PO18 0QZ
t: 01243 811301
e: diplomas@westdean.org.uk
w: www.westdean.org.uk
Offers a range of postgraduate conservation and restoration courses, both specialised and general.

De Montfort University
Student Recruitment, Faculty of Art & Design,
De Montfort University, The Gateway, Leicester LE1 9BH
t: 0116 257 7555
e: artanddesign@dmu.ac.uk
w: www.dmu.ac.uk
Offers a BA (Hons) Design Crafts

The Institute of Archaeology, University College London,
31–34 Gordon Square, London WC1H OPY
t: 020 7679 7495
w: www.ucl.ac.uk/archaeology
Offers an MA in Principles of Conservation, and an MSc in Conservation for Archaeology and Museums

Books

Susan Buys and Victoria Oakley, *Conservation and Restoration of Ceramics*, London: Butterworth-Heinemann, 1996.

Roy Newton and Sandra Davison, *Conservation of Glass*, London: Butterworths, 1989.

Sandra Davison, *Conservation and Restoration of Glass*, 2nd edition, London: Butterworth-Heinemann, 2003.
This book, a new edition of the preceding title, is, in some senses, less complete. For example, the section on stained glass has been removed. Thus, although the first edition is out-of-print (and therefore difficult to obtain) it remains an extremely useful text.

Conservator: Easel Paintings

David Crombie

Senior Paintings Conservator, The Conservation Centre, National Museums Liverpool

Individuals entering this field of the conservation profession will undertake the practical conservation and restoration of a wide range of easel paintings of all types in both public and private collections. They will be working to ensure the proper care of a painting, deciding on appropriate treatment where needed, and securing, as far as possible, its preservation for future generations.

A career in painting conservation can be extremely rewarding, and an experienced conservator may carry out practical work and research on important works of art in a major collection. The range of skills needed by the conservator is broad, and an individual will be required to embrace practical, theoretical, aesthetic and ethical issues in combination. To list a few key elements, the work requires a very high level of manual skill, a sound understanding of the background to the materials and techniques of painting, an aptitude for problem solving and an acute perception of the aesthetics of a painting surface. Knowledge of art history and material sciences, (including some physics and chemistry), is also required. Accurate colour vision is essential.

Job profile

As a paintings conservator, one of the main motivations is the satisfaction of the unique personal contribution to the improved condition and future survival of a work of art. The painting is literally in the conservator's hands, and her/his work, employing the required range of practical and academic skills, enables the painting to be seen and understood to its best possible advantage. The conservator will usually be responsible for all stages of treatment to a painting, which may include structural work and consolidation of loose or flaking paint, varnish and dirt removal from the painting, and the inpainting of losses and application of varnishes.

The conservator may also be involved in research into a number of different aspects of a painting, which can be just as rewarding as the practical treatment side. This could be to identify the pigments and media employed by the artist, or to find out more about the development of the composition of the image through examination by x-radiography or infra-red reflectography. This research may involve collaboration with both curators and conservation science specialists. The results may contribute to an understanding of the art historical context of the work and might be included in publications or exhibition material relating to a particular work or artist. It is fair to say that the opportunities for such research are probably greater in the public than the private sector, although this may vary greatly between different institutions. In the public sector, a conservator's duties will usually extend beyond the practical treatment of paintings to include a wide variety of other responsibilities, such as collections storage issues, specifying and managing environmental control in display galleries and the processing of incoming and outgoing loans of paintings between institutions. With more experience, the conservator may be able to devise new procedures or improved systems in these areas in collaboration with other museum and gallery professionals.

Career opportunities

It would be unrealistic to approach this career without the clear understanding that there are fewer jobs than there are trained painting conservators, and that the jobs that do exist are usually at the lower levels of public sector pay across the UK. Positions in public collections do arise occasionally, although these may only be short-term contract posts, rather than permanent positions. Even in full-time posts in the public sector, career and pay progression can be painfully slow or non-existent. The broader pattern of employment in public collections is now being affected by the overall economic difficulties since 2008, with many institutions seeing cutbacks and a

reduction in the number of full-time staff. It is not clear at the moment what pattern of provision of conservation services within public museums and galleries will emerge over the next three to five years, and conservators face considerable uncertainties.

There are some opportunities in the private sector, though the number of vacancies that arise each year are few, and as with public sector vacancies, competition for positions (normally with established private conservators) is intense. There is the option of starting out independently as a self-employed painting conservator in the private sector, but this is a very difficult path to follow, particularly in the current economic climate. In addition to a studio and equipment, a conservator needs clients, and many private painting conservators will attest to the fact that it can take up to ten years to develop a suitable client base.

FURTHER INFORMATION *see also after* Conservation: An Overview

Courses
There are currently two principal easel painting conservation training courses in the UK, and both are postgraduate at present. The type of degree qualification required may vary between courses and it is best to check each one for specific details. A limited number of students is accepted for each.

The Courtauld Institute of Art
Somerset House, Strand, London WC2R 0RN
t: 020 7848 2777
e: pgadmissions@courtauld.ac.uk
w: www.courtauld.ac.uk
Postgraduate Diploma in the Conservation of Easel Paintings (duration: three years).

Hamilton-Kerr Institute, Cambridge University, Whittlesford, Cambridge CB2 4NE
t: 01223 832040
e: hki-admin@lists.cam.ac.uk
w: www-hki.fitzmuseum.cam.ac.uk
Diploma in the Conservation of Easel Paintings (duration: three years). The Institute also offers advanced internships for conservators who have completed a postgraduate painting conservation training course.

Organisations
Icon, the Institute for Conservation
www.icon.org.uk
Icon has a number of specialist groups; the Paintings Group caters for members working in this field. Job announcements are emailed to members, and are available on the website. For more details see after Conservation: An Overview

The International Institute for Conservation of Historic and Artistic Works, (IIC)
www.iiconservation.org
Membership required to access job advertisements.

British Association of Paintings Conservator-Restorers (BAPCR)
Secretary, BAPCR, PO Box 32, Hayling Island PO11 9WE
t: 0239 246 5115
e: secretary@bapcr.org.uk
w: www.bapcr.org.uk

Conservator: Paper

Alan Derbyshire

Head of Paper, Books and Paintings Conservation
Victoria and Albert Museum

Paper conservators come from a variety of disciplines and backgrounds, including artistic, historical, scientific and craft. Paper conservators need patience, excellent manual dexterity, good colour vision and a thorough understanding of the materials with which they are working.

What the job involves

Paper conservators may be expected to advise on and treat a wide range of objects, including prints, drawings, watercolours, wallpapers, books, theatre models, children's games, Indian miniatures, Japanese prints, and Chinese scrolls. It is important to be able to see the 'bigger picture' and advise on best practice for storage – including environmental conditions – for collections as a whole. However, although some treatments can also be considered generic, each object passing through the paper conservation studio should be individually assessed as to its suitability for treatment.

In addition, conservators – whether they are working in private practice or in museums – are increasingly expected to be able to apply sound business ideas and to have an understanding of project management. Resources are finite, and priorities therefore have to be made with the guidance of conservators, who can advise on which objects should be treated first or which objects may be suitable for in-house display or travel as part of a touring exhibition.

Qualifications

Paper conservators will, normally, have completed one of the postgraduate training courses available in the UK, or indeed throughout Europe and the USA. These courses give a thorough grounding in the materials and techniques of paper-based objects, the internal and external factors that cause their deterioration, how to repair damage that may already have occurred, and how best to conserve them for future generations.

FURTHER INFORMATION

Courses in the UK

Camberwell College of Arts, University of the Arts London
www.camberwell.arts.ac.uk
MA in Conservation (duration 2 years)

Northumbria University at Newcastle
www.northumbria.ac.uk
MA in Preventive Conservation (duration 18 months)

West Dean – The Edward James Foundation
West Dean, Nr Chichester, West Sussex PO18 0QZ
www.westdean.org.uk
Books and Library Materials graduate diploma (University of Sussex Award) (duration 1 year)

Conservator: Textiles

Frances Lennard

Convenor, MPhil Textile Conservation, University of Glasgow

Textile conservation is a multidisciplinary field. It combines scientific analysis, a knowledge of textile history, and techniques ranging from tapestry to modern fibres, with the practical skills necessary to carry out conservation treatments. Textile conservators need an understanding of the context in which they work so that they can recommend and carry out the most appropriate treatments for the objects in their care, as well as being able to provide a safe and secure environment for textiles on display or in storage. Through a close study of the textiles they work on, conservators can find out more about objects and their stories, and contribute to their preservation and interpretation.

Textile conservators work in both the public and private sectors. Funding is increasingly tight, and a substantial proportion of career-entry jobs are now based on short contracts. However, textile conservation offers a fascinating combination of analytical problem-solving and hands-on work as well as the chance to extend and develop knowledge of our rich textile heritage. It is also an international field, presenting opportunities to study and work overseas.

Career-entry programmes are at MA level although it may be possible to find an apprentice-type position in an existing workshop.

FURTHER INFORMATION

Courses

The Centre for Textile Conservation and Technical Art History, University of Glasgow
8 University Gardens, Glasgow, G12 8QH
t: 0141 330 4097
e: ailsa.boyd@glasgow.ac.uk
w: www.gla.ac.uk
Offers a two-year MPhil programme in Textile Conservation. Applicants should have a good first degree, proven manual dexterity and a qualification in chemistry at least to GCSE standard. although experience of textile conservation is not essential, it is an advantage. Some bursaries are available.

Books

Frances Lennard and Patricia Ewer, eds, *Textile Conservation: Advances in Practice*, Oxford: Elsevier, 2010.

A Lister, AJ Rowe, "Hidden Meanings. The Revelations of Conservation" in Mary M Brooks, ed, *Textiles Revealed: Object Lessons in Historic Textile and Costume Research*, London: Archetype Publications, 2000, pp99–108.

Lecturer: Universities

Elizabeth L'Estrange
Camilla Smith

Working as a university lecturer can be a very fulfilling job, but it can often only be achieved after a lot of postgraduate and, sometimes, postdoctoral, experience. It is necessary to have a PhD in order to teach at university level, and this can take up to four years full-time to complete. Prior to this, you will probably also have completed a one-year taught MA. It is important, therefore, to be aware of the investment in time and money that this career path requires. However, during this time, you will become familiar with the workings of a university department and may have the opportunity to become involved in departmental teaching. This experience is essential and will give you a taste of what it is like to teach students in seminars or lectures, how to set tasks, and how to mark essays or exams. As postgraduates are often employed to teach on introductory or survey courses, it will also give you valuable experience of teaching across the spectrum of your subject.

The type of teaching you will be expected to do as a university lecturer will vary, depending on the institution and the size of the department you are in, but you will probably be expected to teach general courses (for example on art history methodologies), as well as offer specific courses and dissertation supervision in your own and related fields.

You should try to build a teaching portfolio during your PhD, and use departmental feedback systems to gather student feedback on your teaching. You could also consider taking a Postgraduate Certificate in Learning and Teaching in Higher Education (PG Cert). Many universities offer this and encourage academic staff as part of their probation to have completed parts (if not all) of it. It will help you think specifically about how to tailor your research to the appropriate learning level, as well as help you devise course outlines and tasks that have viable learning outcomes.

Juggling research, new teaching and a PG Cert in a new position can be a real challenge. If you can get a head start, therefore, do!

In addition to teaching and marking it is likely that you will also be expected to participate in the administrative and recruitment side of the department, through roles such as Exams Officer, Welfare Officer, Admissions Tutor, or by participating on various panels and committees. Teaching, research, and administration all require good organisational and communication skills: a PhD provides good training for this in many ways, but you will also need to be able to respond to different and changing situations, student enquiries, and different teaching environments. It is important to use opportunities such as postgraduate teaching, conference papers, and research tasks to build up your skills in these areas. Moreover, due to more recent developments in academic life, academics are no longer simply able to hide away and do research; part of your way of showing that you are the right person for the job will be to show your ability to work with academic colleagues and support students, as well as communicating with a wide spectrum of different audiences.

Funding
In doing a PhD you will be focusing on your own discrete piece of research which you then develop into publications and further research projects. As teaching positions are relatively few and far between, you may also wish to consider applying for a postdoctoral position that will fund you to carry on doing research, perhaps with some limited teaching, usually for one, two, or three years. Post-docs can be a good way for you to focus on consolidating your publications and research profile, enormously important for the Research Excellence Framework (REF), by preparing your thesis for publication, for example. It will be harder to do this if you go straight into a teaching job, as teaching preparation,

marking, and administrative roles – especially for new staff – can take up an enormous amount of time. Post-docs are offered by the British Academy for study in the UK, and the AHRC funds postdoctoral researchers on specific projects.

In addition, other foundations, such as the Leverhulme Trust, the Alexander von Humboldt Foundation, and the European Union Marie Curie grants allow you to study abroad for a period of two years. You should also consider the calls for postdoctoral researchers issued by institutions such as The British School at Rome, The Getty Foundation, and the Yale Center for British Art. The latter two also offer predoctoral fellowships (The Getty of up to nine months), which offer great experience and look impressive on your CV. Experience in a foreign university can then open up other, local, funding opportunities (such as the CNRS in France, the FNRS/FWO in Belgium, and the DAAD in Germany).

Although postdoctoral grants in the UK and in Europe are highly competitive, they can give you additional valuable experience and are an opportunity to build up research networks, which are important for any future funding bids and collaborative grants. Therefore, although you may have less teaching experience at the end of a postdoc than a colleague who has taken on a series of part-time or temporary positions, funded postdoctoral experience is still considered valuable by potential employers. (See also the FUNDING section.)

FURTHER INFORMATION

Job advertisements
www.jobs.ac.uk

Association of Art Historians – Jobs & Opportunities
www.aah.org.uk/jobs

College Art Association – Career Center
careercenter.collegeart.org/jobs

Times Higher Education Supplement
www.timeshighereducation.co.uk

Lecturer: Open University

Veronica Davies

Associate Lecturer, Open University

The Open University (OU) offers supported open learning for part-time students in the UK and abroad. Most are mature students following undergraduate programmes while working and/or meeting personal commitments. Due to the 'open' nature of the university, many have not followed a conventional educational route to undergraduate study, but often have experience and qualities that compensate for this.

The undergraduate programme generally involves studying modules at three levels, each of which is worth either 30 or 60 points, depending on the amount of study time involved. Students typically undertake 60 points of study per year, with an upper annual limit of 120 points. To gain an honours degree, a student must gain 360 points, 120 of which must be at level 3. Some students are studying for certificates or diplomas; there is also a body of postgraduate students, with a wide range of Masters courses being offered.

Teaching is based on course material written by central academics, most of whom are based at the OU headquarters in Milton Keynes, with some based at one of the 13 regional centres. Material is delivered both as printed texts, including the readers and purpose-written books, for which the Art History department enjoys a high reputation, and, increasingly, online materials. This is complemented by specially produced audio-visual material, and optional tutorials, which may be delivered face-to-face, by telephone or as e-tuition.

Undergraduate courses start with Level 1, where students are introduced to all the disciplines in the faculty. Level 2 courses are mainly broad-based single-subject courses, whilst third-level courses require a standard equivalent to the last year of an honours degree elsewhere. There are also a few second- and third-level interdisciplinary courses. The Arts Faculty also offers a range of MA programmes. The Art History MA started in 2004 and incorporates foundation, subject and dissertation modules.

Employment

For OU employment opportunities, the best source of information is the OU website (see Further Information). All current vacancies are listed there under the general heading 'Jobs at the OU', as well as being advertised in the national press. The following categories of employment exist.

Central Academics

The Art History Department is based at Milton Keynes, but, because of the structure of the OU, this is not a campus with undergraduate students, and the teaching functions of the central academics are to plan, write, deliver, monitor and maintain distance-learning courses leading to BA and MA degrees. The Department also has a strong research base. As with all university posts, vacancies are infrequent and very competitive.

Staff Tutors

The Arts Faculty currently has a Staff Tutor, assisted by Faculty Managers, in each of the OU's regional offices. These are academic posts, with responsibility for the administration of the Faculty's teaching in their region. This includes the appointment of Associate Lecturers to teach in the region, and organisation and oversight of their professional development. Staff Tutors also frequently have a role in the development of new courses as members of module teams. As with central academics, the number of vacancies is small.

Associate Lecturers

Associate Lecturers (ALs) are part-time staff appointed on a regional basis to tutor a particular module. The full range of their duties, and a person specification, can be found on the OU website. All tutors are now expected to

use ICT in some form in their work. A key part of the tutor's role is marking and giving written feedback on students' essays (typically six or seven assignments for a 60-point course). For many students, their module tutor is their main point of contact with the university, and tutors need to be available to individual students by phone, email or letter, as well as running regular (though beyond Level 1 not always frequent) group tutorials.

Full details of the recruitment process are on the website. Advertisements for AL posts appear from time to time, depending on module start dates. There are not always vacancies for all modules or in all regions; there are usually, however, more vacancies when a new module is starting. For this reason you should not be discouraged from applying again if you are unsuccessful the first time, and it is worth looking out for current vacancies on the website.

The current modules of most interest to art historians are as follows:

Level 1: The Arts Past and Present includes a general introduction to the discipline of Art History through study of Cézanne's paintings, Pugin's architecture and design, and the art of Benin. Making Sense of Things: An Introduction to Material Culture builds on this, with study of objects from both past and present. There is a strong element of study skills teaching, and there are more local face-to-face tutorials than with higher levels.

Level 2: Exploring Art and Visual Culture, new in 2012, covers the art of different historical periods from 1100 to the present, and explores how ideas about art have changed over time. Topics covered range from Gothic churches to Impressionist painting, and landscape gardens to photography. Understanding Global Heritage is an introduction to the study of heritage, how it is created and consumed across different cultures, and its roles in contemporary and past societies.

Level 3: There are two level 3 modules. Renaissance Art Reconsidered explores the diversity of artistic practice during the Renaissance, drawing on cutting edge approaches. Art of the Twentieth Century examines critically and in depth the changes in art and related theoretical issues since the turn of the 20th century.

Residential School Tutors

The Art History department runs a 15-point residential school module in London each summer. Tutors are recruited independently for these posts, which are usually advertised in January. Remuneration is quite good, but the week can be demanding and stamina is needed, as well as the appropriate academic skills.

FURTHER INFORMATION

The Open University
Walton Hall, Milton Keynes MK7 6AA
p: PO Box 197, Milton Keynes MK7 6BJ
t: 0870 333 4340
w: www.open.ac.uk

Job vacancies
General staff vacancies
www3.open.ac.uk/employment/jobs-external.asp

Vacancies for Associate Lecturer
www8.open.ac.uk/jobs/tutors/
Fill in an 'expression of interest' form to ensure that you are emailed as new vacancies are advertised. Then follow the guidance on the website.

Art History Lecturer: Art & Design Schools

Robyne Erica Calvert

Tutor in Art, Architecture and Design History, Glasgow School of Art

The UK has some of the best schools of art and design in the world, and since the 19th century has been a pioneer in how creative practice should be taught. Unlike large universities, these schools are subject-specific, with practice-based programmes that can be incredibly rigorous and demanding of a student's time. Historical and critical studies are just one part of this programme.

Although art and design schools are increasingly research-focused (most are accredited through, or in some cases part of, larger universities), these institutions have, perhaps, a more practical goal overall: the education of creative practitioners. Programmes and course structure vary widely between institutions, but I think it is safe to say that one universal challenge for visual culture historians teaching in this context is that the students are not primarily there to study Art History. They are there to become painters, or product designers, or architects. Historical and critical studies exist in art schools to support the practical programme, and make students more well-rounded in their creative practice, but they are not the end goal as they are in university Art History departments. In fact, some students (and in rare cases teaching staff) might see history as being rather unnecessary to learning creative practice – what consequence does Praxiteles have to New Media art, for example? Thus, making your content relevant is essential, and often the best way of doing this is through energy, enthusiasm, and being a bit of a polymath by delivering your content in a creative way that makes connections to current topics in art, and inspires your students.

Related to this, Art & Design departments may want content that is somehow linked to practice, and wish for an approach that defies more traditional pedagogy. This might be challenging if your idea of assessment is solely essays and tests, though these are often still used in art school teaching. However, I personally find this non-traditional aspect inspiring, and enjoy thinking about how to craft assessments that further a student's creative practice, while still teaching them about history and theory. For example, imagine an object-based assessment where fashion and textiles students have hands-on access to primary source material (such as dress and textile collections in local museums and archives), and are given a task first to perform an object analysis *in situ*, then research and write a catalogue essay for an imagined exhibit, and finally to design something based on their research. Alongside more theoretical and conceptual assignments, these kinds of tasks allow art students to learn about research and how it may benefit their own practice.

While teaching history of art in an art school environment might be something of a challenge, it can also be incredibly rewarding. It is always satisfying to see our students take on board what we teach, but for me there is a very special kind of satisfaction in seeing my students inspired by history and somehow manifesting it in their own art and design. Art & Design schools are an exciting, inspiring, and often fun environment to work in – very rewarding, and often exhausting too!

Qualifications

Like many other educational career paths, becoming an educator in a School of Art & Design requires an advanced degree, often a PhD, with a postgraduate certificate in teaching and learning considered an asset.

While not required, a practice-based background is an asset, as understanding the unique environment of studio-based learning is important for success in this field. Many of my colleagues are involved in some form of creative practice, whether hobbyists or fully fledged artists and designers. Also, many of us – myself included – attended art school as undergraduates, and experienced the intensity of sitting through critiques of our work –

something which I believe helped shape our own pedagogical approach. This is not to discourage those who do not have an art school background, but they might find some form of creative, practice-based coursework, perhaps even informally in a local art centre or through lifelong learning courses, would help them gain insight into what the studio environment is like.

Finding a job

The advice offered on qualifications and job-seeking in other sections of this book applies here, particularly in regards to keeping an eye on the vacancies at specific schools' websites, as sometimes temporary or fixed-term appointments come up that don't necessarily make it to the larger job sites.

Also, it is worth contacting departments directly to see if they might have any contract or visiting lecturer posts, particularly if you have some solid course ideas. Walking in the door with ideas of what you want to teach often helps, but make it clear that you are flexible.

FURTHER INFORMATION

Job advertisements
www.jobs.ac.uk

Association of Art Historians – Jobs & Opportunities
www.aah.org.uk/jobs

Times Higher Education Supplement
www.timeshighereducation.co.uk

Teacher: Schools

Caroline J Osborne

The majority of teaching posts are in the independent sector, but employment is also available in some state schools, sixth form colleges, and colleges of further education. There are very few full-time contracts available. Art History is often taught part-time in one or more institutions, or full-time in tandem with a subject such as Art & Design, History, Classics or a language. This makes a joint honours degree in Art History particularly useful. Demand for qualifications can vary enormously, but a BA Honours degree of some kind is necessary; usually this will be in Art History or, if not, an MA in Art History might be expected.

There are various routes available to gain qualified teaching status (QTS), which will enhance both your skills and your remuneration considerably: straight after a degree, alongside a teaching degree, or within a school. Full details can be found at present on the government's Training and Development Agency for Schools website (TDA). Full-time postgraduate initial teacher training (ITT) courses take a year, and include 24 weeks in a school for those wanting to teach at secondary level. At the end of the course, assuming you meet the standards, you will be awarded qualified teacher status (QTS) and become a newly qualified teacher (NQT) ready to undertake your induction year. This postgraduate certificate of education (PGCE) programme through a university would need to be taken in a joint honours subject other than Art History; for example some Art & Design PGCEs contain a Critical Studies component but they are not exclusively oriented towards post-16, and the course content is different from AS and A2 Art History. This would qualify you to teach in a secondary school, including the sixth form from ages 11 to 19 or 14 to 19 in both your designated subject and Art History. Bursaries for fees and maintenance are available for some subjects; check the Access for Learning website. A PGCE can also be undertaken on a part-time basis at a small

number of universities including the Open University. The private University of Buckingham offers a PGCE that includes QTS. It is more expensive than other courses but includes Art History and will immediately enhance your salary once employed.

The Graduate Teacher Programme (GTP) allows schools to employ graduates and work out an individual training programme for them, leading to QTS but not always a PGCE. This is known as school-centred initial teacher training (SCITT). One is paid as one trains, but one needs to find a school willing to do this and such opportunities are rare.

Another alternative, and for many the most attractive, is to do either a Diploma in Teaching in the Lifelong Learning Sector (DTLLS), which is a post-16 educational qualification, or Life Long Learning PGCE (LL PGCE). This will qualify you to work in adult education and community education as well. These are not subject based, and can be carried out part-time, but require that you already have a teaching job. The government is streamlining the process of applying for teaching training through a new Training Agency from September 2014, so check websites for up-to-date information as there are likely to be major changes.

You do not need QTS to teach in many independent schools, but many schools prefer teachers who have it. There is no government funding to complete your training in the independent sector. A common route into Art History teaching would be to gain a part-time position in an Independent School or a Tutorial College and once there undertake a qualification to help build a career.

Remuneration is often better than in higher education, especially in independent schools and boarding schools, which sometimes offer accommodation as part of the job package. Terms are longer than HE, but holidays are

usually a complete break. However, teachers have more pastoral responsibilities than do university lecturers. Some people might be attracted by the opportunities to accompany field trips in the UK and abroad; most teachers are expected to take at least one trip a year during a school holiday. Career progression beyond head of department can be made by applying for additional posts, such as exams co-ordinator. Many teachers also work for the examination boards as markers or moderators.

The actual classroom work is in some ways similar to teaching first-year undergraduates. Classes are often small, comprising as many as 15 students or as few as one. Teaching in schools requires both organisation and flair. A lot of specific information needs to be delivered in a short time, so classes must be prepared for and used efficiently, tests and homework set and marked regularly, and students' learning monitored. There is, however, also an element of theatricality in the work, with the use of images, the vivid presentation of ideas, and interaction with an audience. Since the introduction of digital projectors and the internet, materials are much easier to access, and full use can be made of multimedia and interactive facilities using schools' virtual learning environments alongside more traditional aids for a range of learning experiences. Focus on independent learning and preparation for university is also an important aspect of the teaching experience. Success in the classroom is as much a product of experience as personality, and develops with time.

All this requires energy, especially when accompanied by report writing, parents' evenings, careers evenings, and all the other extras, but it is very fulfilling. Teaching requires the individual to fit into a school hierarchy and timetable, but it also offers an unusual degree of autonomy. A teacher's classroom is her/his own space where s/he can create her/his own standards, methods and atmosphere, so long as excellent results are forthcoming. Additionally, there is the satisfaction of working closely with young people at a key point in their intellectual development, and the enormous breadth of art history tends to inspire and often bring out the best in students during wide-ranging discussions or in front of an actual work of art.

Teaching requires an unusual range of skills, and people with different abilities can find a way to excel. Most of all, the job is dominated by a close engagement with works of art and an opportunity to open them up to others. It can, sometimes, be difficult or lonely, working in a department of one, but galleries have excellent education departments, study days, websites, and teaching aids.

The Association of Art Historians Schools' Group offers support and a forum for discussion, as well as the annual Ways of Seeing Conference for teachers and sixth-form students. It is also publishing a textbook with Wiley Blackwell aimed at supporting new and existing teachers with the AQA AS level syllabus, and working with galleries to produce more online material aimed specifically at AS and A2 Art History.

FURTHER INFORMATION

Teacher training
Training and Development Agency for Schools
www.tda.gov.uk

Department of Education www.education.gov.uk

Access to Learning website www.direct.gov.uk/en
Gives details of funding.

Job advertisements
The Times Educational Supplement
www.tes.co.uk

For information about Examination Boards and syllabuses, see AAH Schools Members Group
www.aah.org.uk/schools

Lecturer: Lifelong Learning & Adult Education

Maureen Park

Lecturer, History of Art, Centre for Open Studies, University of Glasgow

The field of lifelong learning and adult education has expanded significantly in recent years. Government-funded initiatives as well as non-governmental organisations such as The National Institute of Adult Continuing Education (NIACE) promote lifelong learning through widening access to learning opportunities throughout the UK. Many universities and Local Education Authorities (LEAs) offer adult education programmes.

Art History has become an extremely popular subject for adults, and an increasing number of teaching opportunities have opened up to art historians. While few full-time lecturing posts in adult education exist, there are opportunities for art historians to work as part-time tutors. Tutors require a good honours degree and need to have, or to be pursuing, postgraduate qualifications in Art History (e.g. MPhil or PhD).

Teaching adults can be a most challenging and rewarding experience. Mature students return to study for many different reasons, personal and career-motivated. They may have missed out on educational opportunities in their younger years or wish to return after a break in their education due to family or work commitments. Some will be seeking entry to full-time study or to enhance their career prospects. Others will come simply because of their interest in art history. As a result, a class may be composed of those who have little or no prior knowledge of the subject and others who have frequented major art galleries and read widely on art over many years. Tutors need to be sensitive to such diversity and be prepared to take a flexible approach to their teaching. Pitching the lectures at a level appropriate to the class is a skill that is acquired through practice.

Mature students are usually highly motivated, enthusiastic and keen to learn. Because their knowledge base and life experience is broader than that of younger students, they can often ask challenging questions, and tutors can learn a great deal from the experience. Adults pay for these classes and expect high levels of knowledge, professionalism and commitment from their tutors; therefore, good preparation is essential. Tutors are expected to provide student support material for each class – course notes, bibliographies of recommended reading, useful websites, etc. Devising a new course of lectures is time-consuming and the rate of pay often low, but the experience of teaching adults is an excellent learning opportunity for young graduates.

Most classes will be taught, daytime or evening, on campus, but some learning providers also offer off-campus work. For example, Glasgow University's Centre for Open Studies provides courses throughout the west and south-west of Scotland. Types of courses include general interest classes with no course work; classes with a small amount of assessed work; and courses carrying qualifying credit at all levels of undergraduate work, requiring full assessment and marking by tutors. Courses can run for a period of a few weeks, one semester or the full academic session, September or October to June. Study days on a specific topic such as an artist or school of painters coinciding with major exhibitions of their work are also popular. Most courses will require a minimum number of students (usually about twelve) before the class will run. Unlike mainstream university teaching, classes may begin small, affording the tutor an opportunity to get to know the class. Mature students tend to become loyal to a tutor and may wish to attend further classes, so, while some classes can be repeated annually, it may become necessary for tutors to design new courses each session.

Teaching adults is demanding but the benefits can be significant. Observing the progress of new students, with no previous knowledge of art history, as they become enthused by the subject, reading books, visiting art

galleries, talking and writing fluently on art, is a rewarding experience. For lifelong learning tutors, the experience of preparing and delivering a range of Art History courses within their specialist subject can enhance their future career prospects. Many tutors who have gained early experience in lifelong learning have gone on to find full-time teaching posts in university Art History departments.

FURTHER INFORMATION

Job advertisements
The Times Higher Education Supplement (THES)
www.timeshighereducation.co.uk

Local and national press
It is also highly recommended that you write directly to universities or local authority education departments, enclosing course proposals and a full CV. If you receive no response, follow this up with a phone call or email. Recruitment of new part-time tutors is busiest in the period, January–May.

Organisations
The National Institute of Adult Continuing Education – England and Wales (NIACE)
21 De Montfort St, Leicester LE1 7GE
t: 0116 204 4200/4201
e: enquiries@niace.org.uk
w: www.niace.org.uk

NIACE Dysgu Cymru
3rd Floor, 35 Cathedral Rd, Cardiff CF11 9HB
t: 02920 370900
e: enquiries@niacedc.org.uk
w: www.niacedc.org.uk

The Open University
www.open.ac.uk

The Open University Scotland
www.open-university.co.uk/Scotland

Department for Education
Castle View House, East Lane, Runcorn, Cheshire, WA7 2GJ
t: 0370 000 2288
w: www.lifelonglearning.co.uk

Workers' Educational Association
www.wea.org.uk
(See also article on Workers' Educational Association for complete details.)

Courses
Only a few university education departments offer postgraduate training in adult education. Details can be found in the current NIACE Adult Learning Yearbook. Most adult education providers will have informal training and support programmes for their tutors.

Books/journals
Alan Rogers, *Teaching Adults*, fourth edition, Buckingham and Philadelphia: Open University Press, 2010.

Yvonne Hillier, *Reflective Teaching in Further and Adult Education*, second edition, London and New York: Continuum, 2005.

Adult Learning Yearbook, Journal of Adult and Continuing Education (JACE), *Studies in the Education of Adults*, all published by NIACE www.niace.org.uk

Tutor: Workers' Educational Association

Sophie Bostock

Tutor, Workers' Educational Association (2010–11)

The Workers' Educational Association (WEA) was founded in 1903. Its original intention was to support the educational needs of working men and women who could not afford access to higher education. Today, the WEA provides courses for adults of all ages and from all walks of life whilst still maintaining its original philanthropic ethos.

The national organisation of the WEA is divided into a number of regions, with a central office in each region, and Tutor Organisers working on a more local basis to arrange the programme of courses in consultation with local branches.

Art History courses comprise a popular part of this local provision, in the form of daytime or evening classes, usually of 1½ to 2 hours duration, with courses lasting anything from six weeks up to 20 weeks, over two terms. Potential tutors should contact the appropriate Regional Office; details can be found on the website (see Further Information). It would be useful to work out the sort of courses you can offer before approaching the WEA.

In my case, the teaching opportunity was quite serendipitous. I sent a speculative letter together with a proposal to teach a course on Venetian art to the WEA's London office, and was subsequently contacted by its course co-ordinator who explained that one of the London branches had just lost a tutor scheduled to teach a course on Venetian art. Following an interview, I was appointed as an Associate Tutor and delivered a 20-week course on Venetian Art from Byzantium to the Late Renaissance to a lively and engaging group of adult learners in southwest London. Further teaching opportunities within the WEA then arose as a result of leading this one course.

The advantages of tutoring for the WEA include the opportunity to design your own courses and to teach the broad range of learners you will encounter. I enjoyed the autonomy of planning my courses and this has certainly placed me in a strong position when applying for other teaching and fellowship positions, particularly in the United States, where applicants are often required to submit course outlines and teaching portfolios as an element of the job application. As an early-career scholar I found the overall experience invaluable. Staff development activities, including an induction and the possibility of acquiring the qualification 'Preparing to Teach in the Lifelong Learning Sector' (PTLLS) are available.

The disadvantages are that, in common with many other similar organisations, the hourly rate has to be seen in the context of the amount of preparation and travelling you may have to undertake, and reimbursement of expenses is limited. That said, in our current economy, it is undeniably advantageous to be practising in one's specialist field and gaining experience whilst waiting for that full-time permanent contract to arise.

FURTHER INFORMATION

Workers' Educational Association
www.wea.org.uk/

Preparing to Teach in the LifeLong Learning Sector (PTLLS)
www.ptllscourse.co.uk

Art History Tour Lecturer

Nicholas Friend

Director, Inscape Fine Art Study Tours Ltd

You can approach the teaching of Caravaggio in several ways, but the most effective by far is to see his work in context. In Naples, his *Seven Acts of Mercy* is in the church of Pio Monte della Misericordia, at the heart of Naples' ancient Greek street-plan. This is not Paris: such streets are not boulevards. To take a group of students to see the Caravaggio, you must elbow your way through Naples crowds, unable to see where exactly you are going, hoping that your group of art history aficionados is still following you and has not diverged down a side street, to be seduced by the Camorra and never seen again. Naples is dangerous; a boy on a scooter may come up at any time, slit the leather strap of your shoulder bag with a razor blade and be away with it. Tour leaders wishing to avoid Neapolitan police procedures ban jewellery and handbags while in Naples, and swallow protests of utter dependency on both from their students.

You carry on, but just before you get to the dark entrance to the Misericordia, you feel you must stop, in order to prepare the group for what they are about to see. The crowd presses, the scooters buzz, you wait for that group member who walks with a stick. They gather round you, blocking the road, and you try to compose a single telling sentence before your little blockage is scolded and moved on. A van passes and threatens to drown your words. Eventually, you gain access to the church. It's 1.10. The church closes at 1.30. The group members are hungry for their lunch. Can you hold their attention and discuss the painting before the doors close?

This kind of teaching is a far cry from the comforts of a lectern in a classroom. To overcome the manifold difficulties of this teaching, you will need the following qualities:

♦ The ability to read a map without hesitation – and preferably to have it memorised.

♦ A good sense of timing, in order to plan your routes and excursions.

♦ A strong, clear and varied voice.

♦ The ability to compose a lecture, on the spot and without notes, in a world of distractions and noise.

♦ The ability to engage your group in discussion. They are not there just to hear you 'guide', but to be aided towards a deeper understanding of what it is they are looking at.

♦ The ability to hold the attention of the group, both by what you say and by how you say it.

♦ The patience of Job to deal with 'the public', whether of the street or of your own group.

♦ Willingness to do battle with whatever may be thrown at you.

Above all you need extreme generosity of spirit. The group must never see your difficulties. If they do, you are not doing your job.

If you can manage these challenges, there is no more rewarding way of teaching art history, no mode of teaching that can bring you closer to what the artist may have intended. What Caravaggio was doing in the church of the Misericordia, as well as following the terms of his commission, was painting the very life of the streets through which you have led your little band of followers. There is quite simply no experience comparable to being there.

If you can manage the kind of challenges indicated above, though your bank account may never be overflowing, your life will be rich in art and alive with grateful students of all ages, sizes and descriptions.

Finding work

Before applying for work as a tour leader on an extended overseas tour, you will need to gain experience of working with adult audiences, perhaps as a lecturer on a

university extra-mural course, a WEA course, or Open University teaching. That might involve you in day trips to galleries or historic houses, and give you an opportunity to find out whether such work is for you. (See also Freelance Art Historian.)

Assuming you decide that it is, you could apply directly to the various tour groups, citing your experience, and including a list of topics, cities, or countries you feel able to lecture on. You may even find someone will take you on a tour as part of a team, so that you can learn the ropes on the job.

The main difficulty of being a successful freelance is that different companies will often ask you to take tours in the same period. Given that you can only accept one contract at a time, putting together sufficient tours to provide a reasonable income can be challenging. But it is rewarding.

FURTHER INFORMATION

Some UK art history tour companies that employ freelance lecturers:

Ace Cultural Tours
www.aceculturaltours.co.uk

Andante Travels
www.andantetravels.com

Art History Abroad
www.arthistoryabroad.com

Inscape Fine Art Study Tours
inscapestudytours.wordpress.com

Martin Randall Travel
www.martinrandall.com

Specialtours
www.specialtours.co.uk

Kirker Holidays
www.kirkerholidays.com

Freelance Art Historian

Tracey Warr

Senior Lecturer, Contemporary Art Theory
Oxford Brookes University

A freelance art historian might curate, write and teach. Integrating diverse practices is key to a robust freelance portfolio. Work includes: teaching adult classes; giving lectures in galleries, museums, exhibitions or for local or national societies such as the National Trust or for the National Association of Decorative & Fine Arts Societies (NADFAS); accompanying study tours in the UK or abroad; undertaking part-time teaching in universities or art schools; researching for books, exhibitions or television; writing art criticism, reviews, articles, encyclopaedia and catalogue entries, textbooks.

Routes into work might include BA Art History, Fine Art or English Literature. Relevant postgraduate qualifications include Curating, Art History, Fine Art, Art Writing. Many teaching posts require a PhD. You need to constantly update your knowledge, and your skillset will include writing, editing, presenting, researching. As a freelancer you are also likely to need accounting, fundraising, press and publicity skills. You will multi-task: working on current projects at the same time as developing future speculative projects and concluding past projects (thanks, legacies, final reports). You will need initiative and resourcefulness and, above all, to be an effective networker.

Voluntary administrative, lecturing, writing, curating work at university or through an internship is worthwhile to gain experience and contacts. To start out as a freelancer without professional connections is like cold calling. Maintaining your own excellent mailing list is an absolute must. Being a freelancer is like a rolling stone gathering moss: to *get* work you have to get *known* so you have to *do* work.

Starting points include writing journal articles, working as a Visiting Lecturer or hourly paid Lecturer, undertaking Open University Art History Summer School Teaching, doing gallery talks and contributing to gallery education programmes. Approach your local gallery and tell them about your specialisms – you may be just what they need. Going to and speaking at conferences will help build your professional network, and your papers may turn into publishable texts. Editorial work is another possible string to your bow. You could start your own magazine or journal. You could run your own art space. You may want to apply for a curator's or writer's residency (see Resartis). You can augment your income with arts administration jobs such as organising conferences. Subscribe to the Arts Council's Jobs email list.

You have to be constantly commissioned and working to survive on what are often small fees. Having low overheads and doing things on a shoestring (staying in youth hostels or camping) helps. You need to invest your time and resources speculatively in research and development work – often international travel. You can arrange to do reviews and ask journals to send accreditation emails to get you press passes for events such as the *Venice Biennale*. You can apply to the Arts Council for research and development funding, including travel to, for instance, *Documenta* and *Munster*. If someone does offer to fund your travel costs you often have to pay upfront and then wait to be reimbursed.

Commissions to write, curate, talk, can come from recommendations by curators, editors, and artists who know your work. Eventually your reputation is such that people approach you based on what you've done before, but you don't have to passively wait for people to offer you work; you can be proactive in initiating and fundraising for your own projects.

It is essential to have an online 'shop window' – a way for people to find your contact details, examples of your work, your CV if they Google you. Wordpress, for instance, is free and easy to use.

Some people have a part-time job and freelance part-time, whilst others go in and out of working freelance or

working for an organisation. If you do that, your career breaks will affect your career path within organisations. (I've had to reapply three times, for instance, for Senior Lecturer status because of my career breaks as a freelancer.) Your freelance career development is based on your growing reputation and expertise, and you can gradually increase what you charge for your services. The advice sheet on paying artists from the organisation 'an' provides useful guidance on remuneration.

In the early days you may want to occasionally work for free if the assignment is interesting to you and will enhance your profile, but once your expertise is developed and your professional network is established you should be absolutely firm about not working for free. People on full-time salaries can write or present at conferences for free; freelancers cannot. If someone asks you to do something and they don't mention a fee, don't play along politely. Ask them what the fee is and get that, the deadline, and the brief in writing.

Register your books, catalogue essays, and journal articles with the Authors Licensing and Copyright Service and you could receive a few hundred pounds a year. Undertaking voluntary positions such as advisory boards for journals or arts organisations can be important for being in the know and connected. Don't limit your remit to the UK: look to teaching institutions in Europe if you are fluent in other languages, or look to some of the European courses taught in English. Collaboration can be very useful. A good collaboration can function as a self-contained research centre, a sounding-board for critical feedback, a motivator. Of course a bad collaboration can put you off for life.

The importance of keeping your ear to the ground cannot be emphasised enough. You have to know what is happening and you have to start to know what is happening before it happens.

The ideal for a freelancer is to have at least one piece of work with a chunky fee plus bits and pieces. Bidding to undertake research for funders and doing consultancy is generally more lucrative than commissions from arts organisations. You have to keep an eye out, juggle, and be working at all stages of the process – getting new work in, working on something, getting money in – all at the same time. And of course, realised projects are just the tip of the iceberg. There are also all the proposals and applications that do not come to fruition but which are still a lot of unpaid hard work.

A holistic practice of joining up the bits so that it all makes coherent sense to you is important. Don't accept commissions that seem completely off-key in relation to your core research concerns. You may get to the point where you need to cut down on small essays and projects, and focus instead on consolidation and larger book or exhibition projects.

The pros of freelancing are the autonomy, doing what you love, flexibility. Balanced against that are the cons: often slow and erratic payment for your work, low rates of pay, no holiday pay, training, sickness pay, maternity pay or other benefits provided by employers, having to provide your own insurance and equipment.

The autonomy and flexibility of freelancing can be beneficial for those with parenting or other caring responsibilities. I began working full-time as a freelance curator and writer when I had a baby. Rather than being the end of my career, this turned out to be the beginning of the most interesting part of my work. Freelancing is likely to be tough financially but it can give you a rich and rewarding career.

FURTHER INFORMATION

an magazine http://a-n.co.uk

Arts Council England www.artscouncil.org.uk
Sign up for free Arts Jobs and Arts News bulletins, apply to Grants for the Arts, read research reports and more

Association of Art Historians www.aah.org.uk
The Independent Members Group is devoted to freelance issues.

Authors Licensing and Copyright Service www.alcs.co.uk

National Association of Decorative & Fine Arts Societies (NADFAS) www.nadfas.org.uk

Open University Residential Summer Schools www.open.ac.uk

Resartis www.resartis.org

Wordpress www.wordpress.com

Archivist

Claire Mayoh

Archivist, Henry Moore Institute Archive

In recent years the profile and understanding of archives has risen, as more and more people are driven to research their family history or locality. Also, businesses now invest in their heritage, rebranding in line with what is found in their documentary past. Archival evidence is at the heart of historical study, with archivists in the privileged position of collecting and sharing these unique materials. For students of Art History, working with archives offers a means of interacting with the primary materials of art historical study. The role offers the unique opportunity to work with artists, authors, curators, students, and scholars, and to contribute to the shaping, and very often reinterpretation, of our understanding of art. This is a fascinating and rewarding area of work, as archives hold hidden histories not only of the art world but of society itself.

Role of the archivist

Archives are created by everyone, as information is captured and communicated in a multitude of formats. Artists form archives through their creative processes, when making work, staging exhibitions, writing catalogues, and in all other aspects of their practice. The materials. collected are wide-ranging: sketchbooks, letters, photographs, diaries, and financial records, through to film, audio, and digital media. An archivist is there to guide those interested in the collections to relevant items, but does not compromise the security and longevity of the materials in the process.

The tasks involved in looking after archives are varied. The starting point is liaison with depositors, and ensuring safe transfer of collections. Newly acquired archives are catalogued, the process by which archivists compile detailed information about the context and content of the collection, to be used as a guide by researchers. Allied to this is preservation and conservation, during which professional standards are also applied to packaging and storage. Archives with high usage or value are increasingly being digitised, with 'virtual' versions being made available online. The final part of the process is to provide access and answer enquiries. Alongside security, archivists also need to be aware of legal restrictions, for example implications of copyright and data protection legislation.

In addition to work with the collections, archivists are involved in promotional activities, such as exhibitions, education initiatives, publications, and presentations, and of more generic managerial tasks, including managing staff, policy making, administering budgets, and fundraising.

The key attributes to being a professional archivist is a passion and commitment to secure and share cultural heritage for current and future generations. The other key skills are an ability to work with many different people and to be logical and organised. Archivists also need to be flexible and forward thinking, for example being up to date with current advances in digital technology to ensure they have the means to collect and manage digital archives.

Job market and career progression

Archives can be found in many organisations, both public and private, encompassing a wide range of subjects beyond art. Records of both historical and current relevance are retained, offering archivists opportunities to work in the management of modern records and media. The main employers are in the public sector, in national archives and museums, charities and higher and further education institutions. Archivists also work in businesses, and self-employment is a growing field. The current job market is buoyant, with many recent graduates securing roles as modern records managers. As in all sectors, a degree of flexibility is required until your preferred role becomes available. Salaries are also commensurate with similar posts within museums, libraries, and galleries, and the Archives and Records Association (ARA) offers

guidance as to suitable levels of pay. Working as a professional archivist offers opportunities to progress, and attain senior management roles in a variety of cultural services and institutions.

Qualifications

To work as a professional archivist you need a first degree (subject not strictly relevant) and a postgraduate qualification in archive studies, recognised by the Archives and Records Association (ARA). Several UK universities (see Further Information below) offer postgraduate courses in both archives and records management. Most of these courses are offered full or part time, and there are opportunities for distance learning. The courses are popular and competition is keen, with applicants recommended to undertake paid or volunteer work in archives prior to application. Paid pre-course archive placements are available at several archives, and further details can be found on the ARA website, and in the national and local press. Jobs in archives and records management are advertised in national and local press, and on the archives-nra email discussion list.

FURTHER INFORMATION

Archives and Records Association (UK & Ireland)
www.archives.org.uk
The ARA offers a wealth of information, events and publications about working in the archive and records management sector, plus job advertisements in 'ARC recruitment'.

Information and Records Management Society
www.irms.org.uk
The professional association for all those who work in or are concerned with records or information management, offering information, job advertisements, training and guidance.

The National Archives
www.nationalarchives.gov.uk
The UK government's official archive, it also offers guidance and advice to public and private archives. It hosts the ARCHON Directory of UK archives.
www.nationalarchives.gov.uk/archon

Artists' Papers Register
www.apr.ac.uk
A list of archival documents relating to artists, designers and craftspeople in publicly accessible collections in the UK.

Henry Moore Institute Archive
www.henry-moore.org/hmi/archive
Archive of sculptors' papers reflecting sculptural practice in Britain from the 18th century to present day.

archives-nra email discussion list
www.jiscmail.ac.uk/cgi-bin/webadmin?A0=archives-nra

Courses
Postgraduate courses in the UK offering study in archives and records management:
University of Wales, Aberystwyth
University College Dublin
University of Dundee
University of Glasgow
University of Liverpool
University College London

Art Librarian

Erica Foden-Lenahan

Tate Library and Archive

It seems irresponsible to encourage anyone to pursue a career in librarianship at the moment as both the library and education sectors are shrinking. However, it is an international career and working in an art library is an excellent way to use your art knowledge, to remain current with exhibitions and research, and to be surrounded by interesting material. In addition to universities and museums, large public libraries often have art sections.

Libraries are usually structured into different function groups: bibliographic services deal with the acquisition and cataloguing of material, and user services are the public-facing roles, such as reference enquiries. Libraries have embraced new technologies, and you may be responsible for website maintenance, blogs, and other forms of social media. Subject specialists in academic organisations often teach or provide research-support functions. Many people train as librarians and find themselves working on the digitisation of images or books. In smaller facilities, you may work as a solo librarian and be involved in all aspects of service delivery and planning.

Not all work is permanent, and temporary or fixed-term contracts provide avenues to broaden your experience. The recruitment agencies are a good source for contracts (see Further Information). The small and specialised art library world enables you to develop knowledge of artists' books, rare books, archives, still and moving image collections, bibliography compilation, works on paper, and preservation. Budget and general management figure prominently in the work of most librarians, and there can be opportunities for involvement in creating displays or site-specific student projects.

Librarianship is still largely a postgraduate profession, requiring either a graduate diploma or an MA in librarianship or information management. However, it is possible to work in libraries without a formal qualification. The Chartered Institute of Library and Information Professionals (CILIP) (see Further Information) is the professional body, and their website has lists of accredited postgraduate courses. It also has information about certification for para-professional roles within a library.

It is a good idea to have some library experience before committing to a course, and for some postgraduate courses it is mandatory. Experience can be obtained as a library assistant, as a graduate trainee, or as a volunteer. Traineeships are usually one-year fixed-term contracts, and are designed to give trainees exposure to the variety of functions in a library. The CILIP website has details of graduate-trainee vacancies.

Enquiries can range from background and biographical information for obituaries and profiles of artists, to details about a specific work or artist, to identification of an artist's signature, to pictures of animals to provide inspiration for a design student's brief. In other words, an enquiry can be about almost anything. The detail required varies, and doing the research for an enquiry can be fulfilling. It is important for a librarian to be familiar with the general reference sources for art and design. It is also vital that they can exploit the internet and other electronic resources, such as bibliographic databases, to search for journal articles and theses.

ARLIS/UK & Ireland (Art Libraries Society) is the professional society for art librarians in the UK (see Further Information). The Society produces its own journal and members' newsletter, as well as a variety of publications specific to the profession, such as guidelines for weeding stock, and on cataloguing archival material. It has a Students & Trainees committee that run events and workshops for students and new professionals. ARLIS has an annual conference with talks, visits, and workshops,

and provides opportunities to network with other professionals. Libraries are reliant on collaboration with other organisations to get funding and run projects; networking is one of the ways this is facilitated. There is one funded bursary for a student to attend the conference, details of which can be found on the society website.

FURTHER INFORMATION

Recruitment Agencies

Glen Recruitment
88 Kingsway, Holborn Station, London WC2B 6AA
t: 020 7745 7245
e: info@glenrecruitment.co.uk
w: www.glenrecruitment.co.uk

Sue Hill Recruitment
Borough House
80 Borough High Street, London SE1 1LL
t: 020 7378 7068 (London)
t: 01564 773 651 (West Midlands)
e: jobs@suehill.com
w: www.suehill.com

TFPL Recruitment
2nd Floor, Chancery Exchange, 10 Furnival Street, London EC4A 1AB
t: 020 870 333 7101 (London)
e: info@tfpl.com
w: www.tfpl.com

Online jobs websites

www.lisjobnet.com
www.jobs.ac.uk
web.jinfo.com
www.jobsforinfopros.com

Organisations

ARLIS/UK & Ireland – Art Libraries Society
www.arlis.org.uk

The Chartered Institute of Library and Information Professionals (CILIP) www.cilip.org.uk

Journals

Art Documentation
Bi-annual bulletin of ARLIS/NA. Free to members; previous issues and tables of contents available on their website.

Art Libraries Journal
Quarterly publication of ARLIS/UK & Ireland.

ARLIS News-sheet
Bi-monthly newsletter of ARLIS/UK & Ireland. Free to members, the text of past issues is available on the ARLIS website.

CILIP Update
Monthly publication of CILIP. Free to members, with contents and selected texts from the magazine available on the website.

CILIP Gazette
Bi-weekly newsletter of CILIP. Free to members. The place where most library and information organisations post their vacancies.

Image Librarian/ Visual Resources Curator

Jenny Godfrey

Information Advisor/Visual Resources Curator, Library & Information Services, Cardiff Metropolitan University

Vicky Brown

Visual Resources Curator, History of Art Department, University of Oxford

This profession may be considered a derivative of art librarianship (see Art Librarianship article), though working with different media. As the work demands familiarity with its most common subject matter, many image collection librarians combine a qualification in librarianship with one in Art & Design. Increasingly, however, a wide range of organisations are requiring and providing access to image databases (the Wellcome Library being a well-known example) and so some posts will suit those with knowledge of history, medicine or science as well as art history. In common with other careers associated with the arts, the field is highly competitive.

What is involved?

This can vary greatly within different institutions. Image librarians or visual resources curators are generally employed in the higher education sector and in the museums/galleries world. Some of the routine tasks you might be expected to carry out are: collection management; cataloguing and accessioning new material; picture research; tracking down suppliers and purchasing new stock; digital photography, and electronic-image capture and manipulation more generally, including scanning (where there is no separate photographic/ imaging service department); basic maintenance and installation of data projection and audio-visual equipment (where there is no extra audio-visual support); assisting library users with their image requests, including working through their ideas for seminars or lectures; maintenance of an electronic catalogue (where one exists); training in visual literacy and advocacy and in electronic visual resources.

Where image librarians are involved in digitisation projects, traditional librarians' skills, such as data control, image management and knowledge of copyright, together with technical skills relating to the digital environment, are also applied.

Image librarianship/ visual resources curatorship in the digital age

The role of the image librarian is still shifting and evolving to keep pace with the undeniable increase in demand for digital images, now that slides are an obsolete technology. Although analogue technologies have been replaced with digital, the image librarian or visual resources curator still has an important role to play in the digital environment.

In higher education institutions in the UK, copyright constraints are still preventing large-scale digitisation of slide collections; even if this situation were to alter, it would be both unrealistic and undesirable to digitise entire collections. Instead, institutions are subscribing to commercial schemes, such as ARTstor or Bridgeman Education, purchasing digital images from commercial vendors such as Scholars Resource, and topping up with more specialist material created in-house either from slides, where copyright is owned by the institution, or by scanning from books using the somewhat labour-intensive CLA Scanning Licence.

Subsequently, the role of the image librarian, far from becoming redundant, has evolved into that of an 'image technologist' or 'curator', requiring an additional range of specialist skills and knowledge to match their new role. Where 35mm slide collections and photo archives (albeit pared-down versions in many instances) are still retained

by institutions as image-reference collections, visual resources professionals still have a duty of care for analogue resources, whilst disseminating specialist knowledge of digital resources, with technological skills to match. Although this period has brought about some uncertainty, the wide variety of roles that has come out of the evolution from analogue to digital means that this is an exciting time to become involved in this particular sector. There is also a variety of organisations and agencies that can provide support and advice when required (see Further Information).

Some people who used to work in slide libraries were and still are responsible for more than just a 35mm slide collection: they might first and foremost have been subject specialists with other media to deal with, such as paper ephemera, archives or photographic, or other audio-visual material. In this sense, the role of image librarian very often evolves out of other professions and cannot always be separated from them. Therefore, it should come as no surprise that there is no official qualification or a generally accepted level of education that one must have in order to enter this profession;

however, most will at least have studied to an undergraduate level, and a postgraduate qualification in Librarianship or Information Management is desirable. Indeed, in some universities it is the Art & Design Librarian who will be tasked with managing the need for images and advice on images in their institution, along with their more usual responsibility for the book and e-resources stock and for subject guidance in general. In other institutions the post remains distinct and might be allied with other more technical duties such as setting up equipment for lectures or training staff and students in presentation software programmes such as PowerPoint, or image manipulation software such as Photoshop. In the world of museums, art galleries and archives, where there are many more digitisation projects taking place, the skills of an art historian, especially when allied to those of a librarian, can be usefully deployed.

Finally, some institutions take on students to help out in the day-to-day running of their image collections; this is a useful way of both getting experience and a taste of what is involved.

FURTHER INFORMATION

Organisations
Association of Curators of Art and Design Images (ACADI)
http://acadi.wordpress.com
ACADI provides a useful network of support for Visual Resources Curators throughout the UK.

ARLIS (Art Libraries Society)
VRC (Visual Resources Committee)
ARLIS/UK & Ireland, The National Art Library, V&A, Cromwell Rd, South Kensington, London SW7 2RL
t: 020 942 2317
e: arlis@vam.ac.uk
w: http://arlis.org.uk

CLA (The Copyright Licensing Agency)
Saffron House, 6-10 Kirby Street, London EC1N 8TS
t: 020 7400 3100
e: cla@cla.co.uk **w:** www.cla.co.uk

Visual Arts Data Service (VADS)
University for the Creative Arts, Farnham Campus, Falkner Road, Farnham, GU9 7DS
t: 01252 892723
e: info@vads.ac.uk
w: www.vads.ac.uk/

JISC Digital Media. Institute for Learning and Research Technology, University of Bristol, 8–10 Berkeley Square, Bristol BS8 1HH
t: 0117 331 4447
e: info@jiscdigitalmedia.ac.uk
w: www.jiscdigitalmedia.ac.uk
JISC DM provides advice & support on all matters concerning digital imaging, as well as running practical courses covering the same.

Visual Resources Association (VRA)
w: www.vraweb.org
The VRA is an international organisation for image professionals whose collections mostly support courses in art, design, architecture, and art and design history. Most of these image professionals work in colleges, universities, galleries and museums, predominantly, but not exclusively, in the USA.

Marketing Account Executive

Rebecca Peters

Design Account Executive, Haygarth Marketing Agency

The role of an account handler is to act as the link between the client and the agency. The role is very much involved in the creative aspect of the industry, working closely with designers, which is really where the visual awareness built up during a degree course in Art History lends itself well to the position, as do research and analytical skills.

For each campaign an account handler is working on, the tasks typically involve the following:

♦ Meeting and communicating with clients to discuss and identify their specific requirements for the campaign.

♦ Working with agency colleagues, those on your account team and also in the creative department, to devise a marketing campaign that meets the client's brief and budget.

♦ Presenting the creative concepts the agency has developed to the client, alongside a proposed budget for the completion of the work.

♦ Once the client approves the ideas, briefing the creative team – designers and copywriters – and assisting them in the formulation of the final creative work.

♦ Liaising with the client's marketing team on a daily basis throughout campaigns, making sure the campaigns are completed on time and on budget.

Things don't always run as smoothly as you wish, and so there is a lot of negotiating to be done with both clients and agency staff about the details of campaigns.

We present the creative work to the client at various stages of its completion for approval and/or amendment, and once the work is in a state that the client is happy with, it can go to print.

Of course, the job encompasses much more: from administrative tasks such as managing costs and invoicing clients, to monitoring the effectiveness of campaigns once they have gone live. A significant part of the job is making sure you are aware of the marketing strategies being adopted by other brands, in particular by competitors to your own clients, and reporting these findings back to your clients.

An aspect of the job I find especially enjoyable is preparing for and being part of photo shoots. It has been fascinating to discover how much consideration goes into them, and seeing the final photographs within a brochure you are working on is great. Generally, it is experiencing projects coming to fruition that brings me great delight in this industry. It inspires that sense of achievement and encourages you to do just as well, if not better, on the following project, knowing that all aspects of the project will ultimately tie together, and the endless rounds of proofing will all be worth it.

For a role as an account executive, agencies don't usually ask for any particular qualifications. Yes, there are courses one can undertake in marketing and advertising, but I believe that it is more important to showcase your interest in the industry and individual attributes that you feel would be beneficial to such a career when applying for jobs. Since this job entails dealing with numerous people, both your colleagues and clients, on a daily basis it is, without question, important that you have good people skills. Working in a creative communications agency is very much about teamwork. You must be sufficiently organised to run several accounts at once. If you don't already, you will learn to love lists!

I cannot stress enough the importance of gaining relevant work experience. At the end of my first year I undertook a one-month internship at Bonhams auction house. After completion, I realised that this was not the path I wished to take, but I still see it as good experience as it helped me decide what else I might be interested in. My

attention turned to the advertising and marketing industry and I began applying for work experience for the following summer. I managed to secure a few weeks at two separate agencies. These weeks were invaluable, both in confirming my interest in this area, and by giving me something to put on job applications. Some agencies have formal work-experience schemes or internships in place, but if they do not show this on their website, it is still worth writing to them. Similarly, some agencies have graduate schemes, but at others positions may become available on an *ad hoc* basis.

To prepare for job applications and interviews, I suggest you start reading the trade magazines (see Further Information below). Open your eyes to different advertising and marketing campaigns around you, and start to build an opinion on them. Work out what is effective about them and what is not so effective. You will almost certainly be asked to voice an opinion like this during any application process.

And most of all, good luck!

FURTHER INFORMATION

Institute of Practitioners in Advertising
www.ipa.co.uk

Blogs on graduate schemes in the advertising and marketing industry
http://gradvantage.blogspot.com
http://adgrads.blogspot.com

Industry resources
www.marketingweek.co.uk
www.marketingmagazine.co.uk
www.brandrepublic.com
www.thegrocer.co.uk
www.retail-week.com

Art Critic

Ben Luke

London Evening Standard

As Brian Eno was about to present the Turner Prize to Damien Hirst in 1995, he gave a short speech in which he lamented the lack of 'great explainers' of the arts compared to the prolific number of scientists who had made complex ideas accessible to a wide public. A particularly memorable part of that short speech was Eno's contention that 'the arts routinely produce some of the loosest thinking and worst writing known to history'.

Prospective journalists in the visual arts field would do well to bear Eno's thoughts in mind. There is unquestionably a default language which infuses much writing on the subject, and not just because of specialist terms like chiaroscuro or impasto. The sea of press releases received by art journalists from both public and commercial galleries includes many clunking uses of this philosophical-cum-poetic lexicon, and they sum up the difficult task for the art historian addressing art, and particularly contemporary art, in the popular media, as well as in the arena of more specialist art magazines. If art historians, particularly those whose studies were grounded in critical theory, want to enter into the mass media, many need to embark on a significant process of un-learning.

All but the most established visual arts critics on national newspapers produce a number of different kinds of article, from the traditional exhibition review to an interview profiling an artist or curator to a 'think-piece' or essay informed by a range of commentators. Their job in all those forums is to communicate to a wide range of readers in a way that is clear and accessible, without losing an iota of intellectual rigour. There are many different publications that contain writing about visual art, from the arts pages (both physical and virtual) of national newspapers, to occasional features in those papers' supplements, to specialist art journals including the *Art Newspaper*, *Frieze* and *Art Review*, and the occasional article in consumer magazines.

The first step in art writing is perhaps the hardest, since in order to commission a writer, editors want to see pre-existing articles. There is no foolproof way to establish a foothold in arts journalism. As with many other art-world roles, many start by volunteering. Most editors are extremely busy and unlikely to be able to devote much time to perusing the CVs and cuttings of writers they have not encountered, so taking brief internships with publications might lead to small commissions, as well as prompting a greater understanding of the mechanics of producing publications. Most art magazines have small budgets and overworked staff, so voluntary help is often needed.

One recent technological development has greatly helped the budding art critic: the ease with which one can set up a blog is a huge advance from the pre-internet years, providing an easily accessible route to view a writer's efforts in a clear format. Blogs also allow for crucial regular practice at condensing ideas into words, giving the writer a chance to hone their style and techniques.

In order to gain commissions, it is vital to understand the media you would like to target – to study the sections of the magazine or journal that would best suit you, and use that knowledge in approaching the commissioning editor, usually the editor, deputy editor or features editor at a publication, or the arts or deputy arts editor at a newspaper.

The most important quality you need to possess is a lively writing style, but reliability is also key – an editor needs to know that as well as the copy being well written, it will arrive on time, with careful attention having been paid to the brief. Flexibility is also crucial: accepting commissions on artists or subjects that might not initially appeal or fall within your field of knowledge demonstrates a versatility that can be important in gaining regular commissions.

Many leading visual arts journalists are not art historians, but a grounding in the subject is, of course, an advantage, though media and journalism degrees are of no real significance to most editors. (Shorthand is an advantage to news reporters such as arts correspondents, however.) The most significant professional body is AICA (Association of International Art Critics), the membership of which allows free access to museums and galleries across the world, though to join the latter, you need a proven track record of art writing.

With few permanent roles on art magazines or the arts desks at newspapers, development potential can be limited; the important roles can be occupied for many years. Many writers and critics supplement their journalism with teaching. For freelancers, it is a matter of building up a big range of commissioning editors, and being tenacious and creative in seeking commissions, and it is possible to build a healthy career once a regular stream of commissions flows. Art galleries do take note of writing in the popular media and often commission newspaper and magazine critics to write catalogue essays.

The arts media is, like all other media, in an uncertain place at present, with the increasingly wide acceptance that digital media will steadily eat up traditional magazines. It is not often a lucrative industry – arts journalists who were writing in earlier decades often lament the fees paid for comparable articles today, particularly by national newspapers. Some journalists, myself included, have come from better-paid positions in museums and galleries, and freelance critics, like all self-employed people, are inevitably prone to fluctuating levels of work. A certain pressure also comes with each commission – you are only as good as your last piece of writing, and it is a tremendously competitive industry. But the reason for this is that it is also hugely satisfying, offering wonderful opportunities to experience and interpret a wide range of art, to meet influential artists, directors and curators, and, often, to travel. It is also unfailingly absorbing and surprising.

FURTHER INFORMATION

International Association of Art Critics
www.aica-int.org
www.aica-uk.org.uk

Art Licensing

John Robinson*

Director of Legal and International Services, Design and Artists Copyright Society

*updated version of 2005 entry by Robert Grose

Rights licensing work is an essential part of the arts media and publishing industries. The level of educational qualification required varies. Although some agencies ask for an undergraduate degree and may lean towards the arts, there are plenty of opportunities for working your way up from scratch.

The Design and Artists Copyright Society (DACS) is the UK's collecting society for artists and visual creators, offering three copyright and related rights services to artists and visual creators. DACS was founded in 1984 as a not-for-profit organisation, undertaking copyright licensing on behalf of artists who are members of DACS' individual rights licensing service. DACS also undertakes the collective licensing of artistic works. Collective licensing provides a means for copying to be licensed, and royalties to be paid and distributed to creators, where it is generally impractical for creators to license their work directly. Some examples include photocopying pages of books and magazines incorporating visual works, or recording for educational purposes UK terrestrial channel broadcasts of programmes incorporating artistic works. DACS has negotiated a share of royalties from these sources for visual creators, and pays it to them annually through its payback service. Since 2006, DACS has also administered the Artist's Resale Right. This came in to law on 14 February 2006, and entitles artists to a share of the resale value of their work when it is sold by a gallery or auction house.

Individual rights members include the following:

♦ UK artists and their heirs and beneficiaries

♦ a number of overseas artists

♦ the works of another 60,000 international artists as a result of reciprocal agreements with similar visual art copyright societies (often known as collecting societies) in 27 other countries.

These agreements mean that each national society is entitled to license the repertoires of all the others with which it has agreements. DACS also advises its members on copyright queries.

Collecting societies license copyright material for a fee. A DACS individual rights licence is a type of contract allowing the licence purchaser to use a specific artistic work or selection of artistic works in a range of products, from traditional editorial uses in publications to commercial merchandise. DACS pays 75 percent of any licence revenue to the artist. The terms of the licence will be very specific as to what the licensee (purchaser) can or cannot do with the work – stipulations as to permitted uses may also vary from artist to artist. DACS' role consists then not only in the collection and payment of licence fees on behalf of its members, but also in the protection of the integrity of the work itself and the reputation of its artists.

Legal qualifications are not generally a prerequisite for jobs in licensing, and applicants should not be deterred if they have never studied intellectual property rights. There are many people working in the area of rights licensing with excellent knowledge and experience acquired over the years. One advantage of working in rights licensing is that specialist legal knowledge can be developed relatively quickly. This kind of knowledge is very marketable and may lead to opportunities in the major art institutions or across a broad spectrum of the media. Licensing is a global market and these skills may lead to opportunities to work abroad. A second language is a great asset and will open doors in UK- or US-owned firms with foreign clients or offices.

Individual rights licensing at DACS

Generally, the entry point at DACS is to work as a licensing executive. Licensing executives work to achieve annual revenue targets, and liaise with colleagues on the marketing and promotion of artists and their works. Executives act as a go-between with clients, agreeing

which works may be reproduced. After consulting the artist (or estate) and approving samples of the proposed product, DACS then issues a licence and charges a fee based upon a clearly defined pricing model. Collecting societies must always be aware of the requirements of competition law, and pricing structures must be clear, equitable and not create distortion in the marketplace, either by uncompetitive pricing, or by giving more favourable treatment to a section of licensing customers to the detriment of others. After retaining an element to cover administration (currently 25 percent), DACS pays the remainder of the licence fee to the individual creators.

One of DACS' principal aims is the promotion of artists' copyright. Through licensing activities, DACS aims to address a still-too-prevalent culture in which many people still do not see why they should have to pay a fee to reproduce an artist's work.

Anyone considering a career in licensing should do their homework before applying, because the ethos of an organisation is important in terms of whether an individual fits in and whether they enjoy their work. DACS enjoys a good rapport with the artists it represents and with many of its clients. Licensing work by its nature can occasionally be repetitive and an interest in your artists or your clients is essential. On the other hand, there is great satisfaction to be gained by seeing an innovative use of an artistic work, and knowing that one has worked hard with the artist or their heirs and the licensing customer to bring this about.

DACS does not have a formal work-experience programme at present, but has on occasion in the past recruited students on placement from university arts and media courses to work on specific projects or to undertake research. This may well continue as and when the need arises.

FURTHER INFORMATION

Job advertisements
Arts Hub
e: info@artshub.co.uk
w: www.artshub.co.uk
Arts Hub is a subscription site which advertises arts jobs.

The Guardian – online and currently in Monday and Saturday print editions
w: jobs.guardian.co.uk

Organisations
Design and Artists Copyright Society
33 Great Sutton St, London EC1V 0DX
t: 020 7336 8811
w: www.dacs.org.uk

Book Publishing

Philip Cooper

Editorial Director, Laurence King Publishing

Book publishing is a large global industry. What follows is focused on art book publishing (broadly defined as covering the whole range of visual arts), but much of it applies more generally to other areas of publishing.

One should keep in mind that publishing is a business and, as such, is governed by the need to make a profit. A solid business sense is thus invaluable in whatever area of publishing one works. On the whole, margins in art book publishing are slender and the markets are competitive. Salaries therefore tend to be commensurately modest but it can be a very rewarding career, both intellectually and creatively. Though publishing as a whole is a significant business, art book publishing is quite a small world and, while working for a specialist art publisher is likely to make the best use of one's art historical training, the longer one remains in that field the harder it may be to move into publishing for other subjects. Some skills and experience are transferable, others less so.

The activities of publishers, in whatever field, are determined by the markets they are focused on and, as such, this is the simplest way to divide up the industry, though markets are not always as clearly defined as this would suggest. The following is primarily focused on the UK industry, but many of these companies will have international offices. In addition, there are many companies in other countries that also publish art books.

Types of publisher

Trade: The trade market is the broadest but most unpredictable market for art books and describes the market of so-called 'educated general readers'. It includes 'coffee table' books and more image-led titles. Companies that publish books for this market include most of the specialist firms, such as Thames and Hudson, Phaidon, Taschen, Prestel, Laurence King Publishing, Merrell and Reaktion, as well as the art lists of some of the larger, more general publishers, such as Dorling Kindersley, Pavilion, Orion, and Carlton.

Academic and reference: Books for this market are aimed at other professional art historians. Publishers in this category include most of the above, together with others such as Ashgate, Routledge and university presses (Yale is the major publisher in this field, but there are also the university presses of Oxford, Cambridge, Manchester and others).

Educational: Books for this market are aimed at students in schools, colleges and universities. Many publishers in the above two categories also publish for this market.

Museum and gallery publishing: Increasingly, galleries and museums have their own companies in order to publish exhibition catalogues, books and other printed materials that promote their exhibitions and collections. In the UK, this includes those attached to the Royal Academy, Tate, the National Gallery, the Victoria and Albert Museum and the British Museum.

Publishing roles

There are a number of different roles in book publishing:

Editorial: This is the area where art historical knowledge would be most applicable. It includes the work from commissioning a title to proofreading, copy-editing and indexing. For commissioning, you will need a reasonable knowledge of the subject area, market awareness and good business sense; you will also need to develop contacts to enable you to commission the right authors. Computer literacy is crucial for most editorial tasks, and familiarity with Word and InDesign are perhaps the most important for an editor (see Editorial Roles).

Picture research: Picture research is usually a key role in the production of any illustrated book (see Picture Researcher).

Design: Design is an important feature, especially for art books, and includes not only the design concept (the 'look') but also the detailed page layout of the book. The whole process is now increasingly digital, and so requires good computer skills, as well as creative ones. Most books are laid out using InDesign software and the work tends to be done on Macs.

Production: This covers all the physical stages of a book's creation, primarily origination (the creation of good reproductions of the images) and printing. Production work for art books is fairly similar to that for any other illustrated books.

Marketing and sales: This includes all of the stages required to get the finished books marketed and sold effectively, including liaising with bookshops.

Rights: Publishers often sell the rights to their books to publishers in other countries so as to spread the comparatively high costs of illustrated books. This is usually a dedicated publishing role. Language skills are a distinct bonus, as the job may include foreign travel.

An increasing number of the above roles are filled by freelancers, especially copy-editing, proofreading, design and picture research (see Freelance Art Historian).

Digital/online: This is a fast-changing, new area in publishing, though less well established in art publishing. The nature and structure of work in this field varies widely, ranging from new, primarily technical, tasks to the more traditional roles as applied to the new media (online publications, ebooks, apps etc). Interest in new technology and skills with XML, HTML and other computer languages are all useful for work in this area.

Getting work experience and jobs

Work experience and internships can be obtained in many publishing companies (especially larger companies) though it is often offered on a fairly ad hoc basis. Internships are usually offered from a few weeks to one or two months.

Increasingly it is expected that candidates for jobs will have had experience in publishing through intern positions. Some companies, again the larger ones, have more structured graduate trainee programmes which offer a wide range of experience in different areas of publishing. In addition to first degrees, it is also increasingly common for applicants for publishing jobs to have an MA in Publishing Studies, which are offered by a growing number of universities.

FURTHER INFORMATION *see next page*

FURTHER INFORMATION for PUBLISHING

Job adverts

The Bookseller (UK) www.thebookseller.com

Publishers Weekly (USA) www.publishersweekly.com

The Guardian – online and currently in Monday and Saturday print edition jobs.guardian.co.uk

Bookpeople www.book-people.net

Publishing Jobs www.publishingjobs.org.uk

Recruitment agencies

Atwood Tate
93–95 Gloucester Place, London, W1U 6JQ
t: 020 7487 8314 **e:** info@atwoodtate.co.uk
w: www.atwoodtatepublishingjobs.co.uk

Inspired Selection, Grosvenor Gardens House
Fourth Floor, 6 Heddon Street, London W1B 4BT
t: 020 7440 1500
For positions outside London: First Floor Offices, Golden Cross Court, 4 Cornmarket St, Oxford OX1 3EX
t: 01865 260270
w: www.inspiredselection.co.uk

Judy Fisher Associates
7 Swallow Street, London W1B 4DE
t: 0207 437 2277 **e:** cv@judyfisher.co.uk
w: www.judyfisher.co.uk

JFL Search & Selection
27 Beak St, London W1F 9RU
t: 020 7009 3500 **e:** info@jflrecruit.com
w: www.jflrecruit.com

Meridian
12 Southwick Mews, Paddington, London W2 1JG
t: 020 7402 6633 **e:** search@meridian-recruit.com
w: www.meridian-recruit.com

Reed www.reed.co.uk
Reed's job listings include a substantial media section.

Organisations

Society for Editors and Proofreaders www.sfep.org.uk
Offers training and mentoring programmes in copy-editing and proofreading, and runs an annual conference.

Publishers Association
29b Montague Street, London WC1B 5BW
t: 020 7691 919 **e:** mail@publishers.org.uk
w: www.publishers.org.uk

Society of Young Publishers www.thesyp.org.uk

Women in Publishing www.womeninpublishing.org.uk

The Galley Club www.galleyclub.co.uk
Holds monthly meetings from October to June, with guest speakers and networking opportunities.

Writers' and Artists' Yearbook www.writersandartists.co.uk

Courses

Book People www.book-people.net/colleges.html
Offers listings for publishing training centres around the UK.

Hotcourses www.hotcourses.com
Provides details of universities offering courses in publishing, some at degree level.

London College of Communication
Elephant & Castle, London SE1 6SB
t: 020 7514 6569 **e:** info@lcc.arts.ac.uk
w: www.lcc.arts.ac.uk
Offers publishing training at all levels.

The Publishing Training Centre
45 East Hill, Wandsworth, London SW18 2QZ
t: 020 8874 2718 **e:** publishing.training@bookhouse.co.uk
w: www.train4publishing.co.uk
Offers distance learning courses in editing, copy-editing and proofreading.

London School of Publishing
David Game House, 69 Notting Hill Gate, London W11 3JS
t: 020 7221 3399 **e:** lsp@easynet.co.uk
w: www.publishing-school.co.uk

Chapterhouse
The Glebe House, Whitestone, Exeter, EX4 2LF UK
t: 01392 811642
e: enquiries@chapterhousepublishing.com
w: www.chapterhousepublishing.co.uk
Offers distance learning programmes for those living outside London.

Publishing Courses Around the World
www.lib.sfu.ca/help/subject-guides/publishing/schools

Books and websites

Publishers Weekly www.publishersweekly.com

BookMachine http://bookmachine.org
Includes a news blog and job listings. Its organisers also run publishing networking events within London.

Alison Baverstock, *How to Get a Job in Publishing: A Really Practical Guide to Careers in Books and Magazines*, London: A&C Black, 2008.

Paul Richardson, *A Guide to the UK Publishing Industry*, London: The Publishers Association, 2008.

Editorial Roles

Jacky Klein

Commissioning Editor, Thames & Hudson

Editorial work takes place in many different institutions and on a wide range of publications: from exhibition catalogues produced within a museum publications department or work on a newspaper, magazine, journal or website to the editing of books (both print and digital) within a traditional publishing house. Editing can also be done by a freelancer who is hired on a project-by-project basis. In each of these circumstances, a talented editor will add enormous value to the final publication: correcting errors of fact, ironing out inelegant turns-of-phrase, and in some cases structurally rewriting so that an argument or story is more clearly and persuasively told.

The job requires an attention to detail, patience, diplomacy in dealing with authors, a firm grasp of grammar and syntax, and ideally an avid interest in the area in which the company or organisation is publishing.

One of the best ways to gain experience, and to see if an editorial job suits you, is to apply for an internship or work-experience placement. These are likely to be unpaid but will gain you useful on-the-job knowledge. The most common entry-level jobs are then as junior or assistant editors (where tasks may include proofreading, indexing, captioning illustrations and some copy editing) or as an editorial assistant working for an editor or commissioning editor (a role that is focused more, although not exclusively, on administrative tasks).

The next step up is as a fully fledged copy (or 'desk') editor. This is the person who works through a manuscript in detail, making corrections and suggestions for the author, fact-checking and drafting rewrites. The editor works closely with their commissioning editor, the author, a designer and picture researcher (if the book is illustrated and if the author isn't doing their own picture research) and often a production manager, so strong 'people skills' and a drive to see a project through are essential. The editor may also liaise closely with marketing, publicity and sales people and will need to ensure these members of the team have all the information they need in good time.

While the job of editor is not first and foremost a commercial one, the best editors (especially in an era of competitive pricing and fewer high street booksellers) will always think about the audience for the book, website or magazine they are working on, and will work to ensure that the text is right for its particular readership.

Another key role within book publishing is that of the Project Editor. This person helps coordinate and manage the practicalities of any book (and often many simultaneously), ensuring that everything runs smoothly and schedules are adhered to by the author and the in-house team. A career in editing may lead to more senior roles, which usually require at least five years' experience, such as Managing Editor and Commissioning Editor.

The Managing Editor runs much of the business of the editorial department and has an overview of the publishing programme as a whole, managing staffing and freelancers, work allocations to the editors, in-house progress meetings, budgets and so on.

The Commissioning Editor is usually focused on a particular area of a publisher's list, such as art or architecture, and is the person who develops ideas for new publications and drives them through the publishing house. For this role you will need a steady flow of good ideas for commercially viable books; broad knowledge of your field and a wide range of contacts; the ability to spot trends and identify cultural currents; a good business sense and an understanding of budgets; the ability to negotiate well; excellent interpersonal skills, so that you gain the trust and respect of your authors and staff; and the ability to manage and juggle many projects simultaneously.

Skills required

For entry-level editorial jobs, a basic knowledge of publishing programmes such as Quark and InDesign is immensely useful (though many publishers will also offer you training). A good BA degree is essential and postgraduate qualifications can help, especially when it comes to more senior roles.

There are a number of excellent editing and publishing courses available, though an equally useful attribute for the job is being as well read as possible, and having an open and inquisitive mind. Given the rapid development of the industry in terms of digital products (ebooks, apps and the like), the more you take an interest in digital publishing, the more valuable you are likely to be to a potential employer.

Editorial work is on the whole not particularly well paid, especially in junior jobs. Job satisfaction and enjoyment comes instead from the intellectual and creative nature of the work; your contact with a wide range of authors; working with a (usually) motivated and intelligent set of colleagues; and from the great satisfaction to be derived from improving a manuscript and making it more intelligible and therefore more saleable and successful.

How to get into editing

♦ Apply for internships or work experience.

♦ Check the job pages (some are listed in the Further Information section).

♦ If you know anyone in publishing, ask if they'll meet you and tell you about their jobs, and get any practical advice you can.

♦ Write a punchy, grammatically perfect CV; send it on spec with a clear and confident cover letter to those publishers or companies whom you are most interested in.

♦ For any job, be sure to check in advance the employer's recent list of publications (by asking for their sales catalogues, by looking at their books or magazines etc) and explore the organisation's website so that you are up-to-speed on their publications, design look, backlist and ethos.

♦ Consider alternative roles (e.g. jobs in production, publicity or picture research) in a company you feel passionately about, as these may give you worthwhile experience and enable you to progress into an editorial role.

FURTHER INFORMATION *see after Book Publishing*

Picture Researcher

Pandora Mather-Leeds (2006)
Revised by Rosalind McKever

Picture Researcher, National Gallery Company (2012)

A career in picture research would be suitable for anyone with a keen eye, a good visual memory, organisational skills and an ability to understand clearly and interpret a brief. Because of the potentially broad-ranging subject interests, opportunities are open to graduates from a number of disciplines.

Working as a picture researcher can lead to a variety of roles in a number of diverse areas, ranging from book publishing to working for a greetings card company. In addition, the picture research community has its own industry; you could enter an independent picture library, or one which is part of an institution, such as a museum. The working environment can be flexible, sometimes enabling a researcher to undertake full- or part-time freelance work from home.

Digital imagery has dramatically altered picture research. Budgets are now tighter, and those commissioning research are more demanding in terms of standards and deadlines.

The job
A picture researcher is given a brief, which may require interpretation. It is necessary to clarify the client's requirements, to establish a budget and any deadlines that need to be met at the outset. Verify who will be responsible for receiving the images selected, how and when they will be returned and who is responsible for paying the invoice and terms and conditions of payment. Most images are now supplied digitally, so ensuring that pictures are returned is no longer such an issue, but maintaining accurate records and organised filing systems is essential. An ability to work independently is desirable, but you are always working for a client and so good interpersonal skills are required for the job. Ultimately, picture research is a business and you must deliver value to whoever is paying, briefing or employing you.

It is essential to be proactive in sourcing material, offering suggestions and generating ideas for current and future projects. Clients need to be nurtured and resources cultivated in order to establish and maintain a successful career.

Fulfilling a brief comes with practice and it can be learned by observing experienced researchers. Many researchers have an area of specialism and this, combined with general knowledge and a good memory, will serve you well.

Projects can be diverse, and may require accessing many sources, including picture libraries, institutions, museums and photographers, for the relevant material. This may even require liaison with overseas institutions. Be aware that some charge hire or service fees, expenses that will have to come out of the client's budget. Obtaining the images at a reasonable price and to deadline may require tenacity and excellent interpersonal skills.

Skills and qualifications
Qualifications can vary according to the employer. Without a degree it may be possible to find an entrée through a junior position or work experience and internships. For many employers a degree is a minimum requirement, preferably accompanied by some relevant experience. Picture research courses are available but are not a prerequisite for finding employment.

Speaking foreign languages can be very useful, particularly those relevant to the area you wish to specialise in. Familiarity with image editing software, such as Adobe Photoshop, photographic processes, and the workings of publishing production can also be advantageous.

Finding a job
Find out the key players in the area that interests you the most, such as Getty Images for picture libraries, Penguin for publishing, and the BBC picture research desk for TV.

Be aware of key issues affecting the industry and keep abreast of them. Examples include copyright changes, technological developments, buyouts, takeovers, and issues affecting pricing and supply of pictures.

Join any relevant organisations that admit non-industry members.

Research the different jobs available in the industry and individual companies you are seeking to join. In a picture library a picture researcher is just one of many roles, not the only option, and it is always possible to make a sideways move from an existing job. The Bridgeman Art Library, one of a number of art libraries in the UK, is a fine-art photo archive and requires arts graduates for picture research or cataloguing. However, there are also other options in the company, such as rights negotiation, marketing, administration, scanning, working with contemporary artists, IT or PA work.

Consider how you might establish a connection with a potential employer. Ask if you can shadow a researcher for a day, or if you can do a week's/month's voluntary-work experience. Enquire about an internship (even if no programme currently exists); be sure to tell the employer if you have a skill you can offer during your internship. The Bridgeman Art Library offers work experience in all its offices and has an official internship programme open to anyone in its New York office.

FURTHER INFORMATION

Organisations
ARLIS (Art Libraries Society). ARLIS/UK & Ireland
The Courtauld Institute of Art, Somerset House,
The Strand, London WC2R 0RN
t: 020 7848 2703
e: arlis@courtauld.ac.uk
w: www.arlis.org.uk

British Association of Picture Libraries and Agencies
(BAPLA)
18 Vine Hill, London EC1R 5DZ
t: 020 7713 1780
e: enquiries@bapla.org.uk
w: www.bapla.org.uk

Design and Artists Copyright Society (DACS)
33 Great Sutton St, London EC1V 0DX
t: 020 7336 8811
e: info@dacs.org.uk
w: www.dacs.org.uk

FOCAL International
(The Federation of Commercial Audiovisual Libraries
International Ltd)
Pentax House, South Hill Avenue, South Harrow HA2
0DU
t: 020 8423 5853
e: info@focalint.org
w: www.focalint.org
An organisation specialising in picture research in moving footage and TV.

Picture Research Association
c/o 1 Willow Court, off Willow St, London EC2A 4QB
e: chair@picture-research.org.uk
w: www.picture-research.org.uk
Contains much useful material, including an information pack with careers information.

The Association of Photographers (AOP)
81 Leonard St, London EC2A 4QS
t: 020 7739 6669
e: general@aophoto.co.uk
w: www.the-aop.org

Books/magazines/newspapers
Hilary and Mary Evans, *Picture Researchers' Handbook*, 8th edition, Leatherhead: Pira International, 2006.
Available from:
Mary Evans Picture Library
59 Tranquil Vale, Blackheath, London SE3 0BS
t: 020 8318 0034
e: pictures@maryevans.com
w: www.maryevans.com

Julian Jackson, *Picture Research in a Digital Age* [ebook]
www.picture-research.org.uk/prda.htm

Media Week
www.mediaweek.com/mediaweek/index.jsp

Publishers Weekly
www.publishersweekly.com

Working in a Museum or Art Gallery: An Overview

Tamsin Foulkes

Collections Assistant, The Barber Institute of Fine Arts, University of Birmingham

Working within the curatorial or collections department of an art gallery or museum can be incredibly rewarding. For those of you who are passionate about art and wish to contribute to the day-to-day care of a collection, furthering research and engaging visitors with objects to be enjoyed and appreciated, then this is the career for you. My own career path is outlined below and aims to offer an insight into how I acquired this role, what it is like to work in a small art gallery, and my main responsibilities.

Job profile

Prior to starting university I undertook a short period of work experience at the Victoria and Albert Museum to get a sense of what it was like to work in a museum environment. This cemented my decision to study History of Art at the University of Birmingham, chosen primarily because the department was situated within the university's museum, The Barber Institute of Fine Arts, which offered an excellent learning recourse. (Other university-based museums include The Whitworth Art Gallery, Manchester, Fitzwilliam Museum, Cambridge, and the Ashmolean Museum, Oxford.)

Gaining a job in the museum sector is becoming increasingly competitive. I therefore cannot stress enough the importance of acquiring work experience or an internship in order to gain practical skills and knowledge, and an understanding of the variety of career options in the art sector. Throughout my undergraduate and postgraduate studies I secured placements at various institutions, such as Sotheby's Auction House, Bonham's Auction House, and the Ashmolean Museum, and I regularly volunteered at The Barber Institute of Fine Art. These experiences helped me to decide that I wanted to pursue a career in a learning-based art museum, rather than in a fast-paced commercial arts sector.

In addition to acquiring work experience, achieving the position of Assistant Curator or Curator usually requires a postgraduate degree. This either involves studying for an MA or MPhil at a university where students are encouraged to choose a specialised area of research or can work towards a vocational museum studies qualification. In order to maintain the balance between academic and practical training, an increasing number of history of art departments are entering into partnerships with nearby museums and offering an exhibition module to their postgraduate students.

Museums and Galleries can range from large institutions with hundreds of staff, such as the British Museum, to collections that are cared for by a few full-time staff or volunteers. I acquired my position as Collections Assistant at the Barber Institute of Fine Arts shortly after completing my postgraduate study. The Barber is a cultural gem of the West Midlands, with a collection of old masters paintings of outstanding merit. It is an independently run museum, managed by a board of trustees. Museums and galleries are also funded by other bodies, such as national institutions that are government funded (National Gallery or the National Museums of Scotland) and local authority museums run by the county or district councils. The Barber has an extensive exhibition and educational programme, with a team of around 20 staff who work in various roles (marketing, front of house, security, learning and access, collections, exhibition planning, administration).

My responsibilities can be split loosely into:

1. Overseeing the day-to-day care of the gallery and the permanent collection of paintings, works on paper, and sculpture.

2. Working alongside the curatorial technician during the installation and de-installation of temporary exhibitions.

3. Updating the collection management database (Mimsy XG), the inventories of objects in the collection and object files, and answering public enquiries. These tasks are also carried out under my supervision by volunteers and interns.

4. Researching the collection and curating temporary displays.

5. Packing, or supervising the packing of objects being sent to exhibitions at other museums.

There are many positive aspects to this job, such as the opportunity to develop a close relationship with the art works, engaging with the public and various professionals in the arts sector (art dealers, conservators, freelance curators, academics), and international travel. The arts community is smaller than you think, so you have the opportunity to make some strong networking links. Pay can be low at entry level, but the opportunity to work in an interesting and creative environment usually makes up for this.

FURTHER INFORMATION

Job advertisements
Museum Association
www.museumsassociation.org/careers/find-a-job

Museum Jobs
www.museumjobs.com/uk

National Museum Directors' Council
www.nationalmuseums.org.uk/jobs

The Guardian
jobs.guardian.co.uk/jobs/arts-and-heritage

University of Leicester Job Desk
www2.le.ac.uk/departments/museumstudies/JobsDesk

Victoria and Albert Museum
www.peoplebank.com/pb3/corporate/vam/index.htm

Sector 1 (Public sector jobs)
http://sector1.net

Local Press

Local Authority websites

Museum / gallery websites

Postgraduate study
Courses in Museums Studies are offered by:
University of East Anglia
University of Glasgow
University of Leeds
University of Leicester
University College London
University of Manchester
Newcastle University
Salford University
University of Ulster
Further details from www.postgraduatesearch.com

Courses in Curation are offered by:
Birkbeck, University of London
Chelsea College of Art & Design, University of the Arts, London
The Courtauld Institute of Art, University of London
University of Edinburgh
Edinburgh College of Art
University of Essex
Goldsmiths, University of London
Kingston University
Liverpool Hope University
London Metropolitan University
Manchester Metropolitan University
Northumbria University
Royal College of Art
University of Sunderland
University of Sussex
University of the West of England, Bristol
Further details from www.postgraduatesearch.com

Victoria and Albert Museum, London
EDI Level 4 Diploma for V&A Assistant Curator Programme (QCF) http://vamnvqcentre.co.uk

Associateship of the Museums Association (AMA)
www.museumsassociation.org

Professional Associations
Museums Association – Associateship
www.museumsassociation.org/professional-development

Publications
Timothy Ambrose, Crispin Paine, *Museum Basics*, 3rd Edition, Routledge, 2012.

Sandra Dudley, *Museum Materialities: Objects, Engagements and Interpretations*, Routledge, 2009.

Communications Officer

Rose Dempsey

Head of Communications, Serpentine Gallery

Communications, marketing and press departments within arts organisations are concerned with creating and implementing communications and marketing campaigns and overseeing all public-facing aspects of an organisation, including:

♦ press and publicity

♦ website and digital communications

♦ printed communications (programmes, leaflets, flyers and invitations)

♦ audience research and development

♦ brand development and marketing.

A communications officer will take both a supporting and proactive role within these departments, assisting the head of press or communications on major campaigns and taking the lead on specific media plans for smaller projects.

Researching target audiences and media outlets, and proactively promoting the work of an organisation is central to the role. Promotional activities might include researching and writing compelling press releases and comprehensive briefing papers, as well as proactively pitching news stories, features, reviews and listings across a wide spectrum of print, broadcast and online media.

Media monitoring is also key to the role, as it essential to track all relevant media within the sector and identify opportunities for coverage.

The communications officer will also arrange photo-calls, press events, briefings and press desks, and assist on the administration of these events.

The marketing/communications department usually liaises closely with other departments, such as programming, development, and directorial, so fostering excellent relationships with colleagues both internally and externally is key.

Working at the Serpentine

The Serpentine Gallery is one of London's best-loved galleries for modern and contemporary art, attracting up to 800,000 visitors a year to its exhibitions, architecture, education and public programmes.

It is known for innovation in contemporary arts, inventing new formats such as the world-renowned annual architecture commission The Pavilion, its Marathon presentations, and its pioneering public and education projects.

The gallery presents five exhibitions a year and one architectural commission, alongside a wide range of public and education programming both at the gallery and off-site.

A PR and communications campaign for an individual exhibition or project at the gallery will typically include:

♦ contributing to the overall positioning of the project

♦ pitching stories to the media

♦ liaising with the artist or artist's estate

♦ developing a content plan for the web

♦ working with media partners and stakeholders

♦ running press conferences and briefings

♦ identifying and targeting audience groups

♦ devising a digital marketing campaign

♦ writing or commissioning supporting materials for the media or for digital use.

The Head of Communications at the Serpentine oversees and implements a PR and communications strategy for the whole organisation, with the purpose of raising awareness of the gallery and its programmes among the public, and of positioning the gallery so it continues to attract funders and donors.

Qualifications

A love of communicating art to a wide audience is essential for work in this field. Degrees in Art History, Journalism and Media are all useful backgrounds.

Articulating the sometimes complex themes in contemporary art and architectural practice to a general audience is a skill that comes naturally to a graduate with some experience of journalism.

FURTHER INFORMATION

Job advertisements
The Art Newspaper
www.theartnewspaper.com/jobs

Dezeen
www.dezeenjobs.com

Arts Marketing Association www.a-m-a.co.uk
Membership required in order to access jobs adverts.

Communicating the Museum
http://agendacom.com/en/about/opportunities/
Offers internships

Other recommended websites
www.frieze.com

http://artforum.com

Curator: National Museum

Heather Birchall

National Museums and Galleries can have up to a thousand employees. However, curatorial departments in these institutions tend to be relatively compact, and curators often focus on one specific area or period. At Tate Britain, for example, teams of three or four curators are assigned to organise exhibitions or write publications on the period of their expertise.

Since nationals have so many resources, including press, marketing and learning departments, and teams of conservators and technicians, curators are able to spend time researching (often a luxury in non-nationals). There tends to be a greater focus on acquisitions than in non-nationals, so as well as organising displays and exhibitions, curators spend a lot of time visiting dealers, auction houses and artists to source works for the collection. Sometimes it is necessary to complete funding applications to organisations such as The Art Fund or Heritage Lottery Fund to enable acquisitions to go ahead. Curators are also responsible for keeping in touch with future donors.

Curators are encouraged to publish as much as possible both at work and in their spare time (lists of publications are included in Annual Reports). Funds are often available to attend conferences, and to travel to exhibitions at other museums. Curators in nationals also have responsibilities to assess applications sent in from non-nationals to the Acceptance in Lieu scheme.

There is no set route to working in a national museum or gallery, although a degree in Art History (even if you specialise in Art History only at MA level) is essential, and it is unusual to find people without at least one postgraduate qualification. It is advisable to undertake as many work-experience placements as possible; it not only looks good on your CV, but will give you an idea of the area and kind of institution you would be best suited to. The Assistant Curator Programme at the Victoria and Albert Museum is also a great way in to the profession.

Employers are keen for curators to have written books or authored articles in journals. Public speaking is also a useful skill, as curators often give tours of the gallery or host events for donors. However, few things count for more than passion, enthusiasm and ideas. For example, at the interview stage it is worth thinking about the kinds of exhibitions you would mount, and having a list of potential research projects to hand. It is nearly always essential to have held an internship or done relevant work experience and, as with many other professions, it is worth making contacts by arranging meetings with curators.

Unfortunately, permanent contracts are scarce and, even more frustratingly, many positions are either only advertised internally (sometimes it is worth taking an administrative position in order to have the opportunity to apply for all available jobs), or can only be found on the institution's website. Although pay tends to be similar to non-nationals, the position usually comes with generous pension and maternity benefits. In addition, employees of national museums are given a staff card that allows them to visit other museums and exhibitions free of charge.

FURTHER INFORMATION *see after* **Working in a Museum or Gallery: an Overview**

Curator: Local Authority Museum

Marie-Thérèse Mayne

Assistant Keeper of Fine & Decorative Art,
Laing Art Gallery, Tyne & Wear Archives & Museums

A Local Authority post is ideal for someone who wants to experience the whole range of tasks that working in museums and galleries can entail. Local Authority Museums and Galleries can vary widely in the number of employees they have, and while some will have teams of up to 30 people, others may have only one or two permanent staff, or rely heavily on volunteers. While it is often possible to draw on different departments within the Local Authority, such as Finance or ICT, more often than not staff in museums have to be a 'Jack of all trades', working on exhibitions, loans, collections care, public enquiries, documentation and education-related activities. Research and writing for publication is encouraged, but is often a luxury to be fitted in around other, more pressing, tasks, so may be something a curator must do outside working hours.

Working in such close proximity to the Local Authority it is essential to be a powerful advocate for the museums service: often liaising with councillors, local businesses and outside agencies such as the Arts Council. Venues are often approached by members of the public offering items for the collections through donation or bequest, and it is important to encourage such donors, as this is often the main way Local Authority collections grow. It is also important to build and maintain relationships with local dealers, auctioneers, and artists – if they know what type of objects your collection is looking for, they will generally alert you to forthcoming sales: an invaluable service for the curator who cannot spend a lot of time searching for new acquisitions. Budgets are generally very limited, and so it is usually necessary to submit funding applications to organisations such as The Art Fund if acquisitions are to go ahead.

Professional networking is also invaluable, as few Local Authority curators look after a single collection specialism. For example, a paintings specialist may also have to look after ceramics or silverware, and knowing someone in another museum who happens to be an expert in these fields can lead to the exchange of knowledge, saving time, money and effort in research and allowing the collections to be more widely used and interpreted. Unfortunately, funds to attend conferences or travel to exhibitions at other museums are limited, and priority often has to be given to those journeys that are directly work-related (e.g. visiting an exhibition that will shortly tour to your venue).

Most curatorial positions within Local Authority museums and galleries ask for a degree in a subject related to that particular collection (essential), together with a postgraduate museums qualification (desirable). Often Associateship of the Museums Association (AMA) is also listed as desirable (this is a professional qualification gained through the Museums Association, and demonstrates a commitment to Continuing Professional Development). Experience of working within museums/galleries is essential, and this is often obtained through work-experience placements, internships, volunteering or short-term contracts. As well as broadening your range of experience, placements such as this give you a taste of different museum environments, help you to decide what kind of organisation would suit you, and are regarded on your CV as showing your commitment to the profession. If you are volunteering in a place where you would especially like to work, it also means you will be first to hear of any jobs coming up!

Public speaking is also a useful skill, as curators often give tours of the gallery, talks to various groups about the collections, or host events for stakeholders. If a museum's collection has a particularly local emphasis, being able to demonstrate knowledge of this history and even specific objects in the collection is an advantage. However, as with so many jobs in this field, an enthusiasm and passion for your subject that shines through at interview will always be looked on favourably.

Because of the regulations surrounding Local Authority recruitment, positions are usually advertised widely – appearing on the Local Authority website, the venue's website and local press, as well as specialist sources such as the Museums Association. However, this also means that direct applications cannot be considered, so sending an unsolicited CV to a Local Authority museum will not benefit the job seeker. Permanent contracts are rare, and many positions, especially at entry-level, are short-term and project-specific, lasting for anything from three months to three years. These are sometimes tied in to the end of the financial year, with the option of renewal if funding is still available.

Pay tends to be at the lower end of the scale (entry-level posts will start at about £15,000 per annum), and while in previous years this was offset by a generous pension scheme, new regulations coming into force mean that this may no longer be the case. However, maternity/paternity benefits remain good, and working terms and conditions are usually favourable.

FURTHER INFORMATION *see after* **Working in a Museum or Gallery: an Overview**

Curator: Country House

Adam White

Curator of Collections, Lotherton Hall, Leeds Museums and Galleries

So you want to work as a curator in a country house? Are you quite sure? Wouldn't you be better off doing something else? The hours of work are long, the pay is poor, the jobs are few, and most of those are on short-term contracts.

If none of the above puts you off and you are resolved to go ahead, then you have passed the first test of suitability for the profession. For two things that you will certainly need are determination and a willingness to disregard pessimistic advice. There *are* jobs and you *might* get one of them, *if* you persist.

Britain's country houses have been described as one of the nation's greatest contributions to Western civilisation. A census of them, based on data collected in the 1930s, produced an estimate of 5,000. That was before the taxation system, an agricultural depression and death in wartime had taken their toll. It is believed that at one point in the 1950s country houses were being pulled down at the rate of one a week by owners who could see no future for them outside the breaker's yard. Many others were converted to institutional use after their contents had been removed elsewhere, but at the same time a minority of owners – usually those who still had some money left – realised that people would pay to see their ancestral homes and that the old mansions and estates could make money as safari parks, banqueting suites etc. Meanwhile, in the 1930s, the National Trust had launched its Country Houses Scheme, with the specific purpose of rescuing houses, retaining their contents where possible and opening them to visitors. The results of all this effort can be seen in Hudsons Heritage directory of houses open to the public, which can be a useful starting point in a job search.

Country house visiting is now a national pastime, and the process of making the houses viewable requires a great many staff. Most of the jobs are in cleaning, security and administration of one kind or another. Aspiring curators should be prepared to take on these roles for at least part of their working day and not expect to enjoy the *bellisima existentia* of the old-fashioned (and largely mythical) curator-connoisseurs who could spend their time admiring an exquisite piece of porcelain and trying to decide if it was real Meissen or a cheaper imitation.

The biggest owner of country houses open to the public is the National Trust, which covers England, Wales and Northern Ireland; there is a separate National Trust for Scotland. The two trusts employ few curators, but the NT now gives a great deal of power to its property managers, who have taken on many curatorial functions. These are not entry-level posts but some of them have assistants and it is here that you may do well to look. Show commitment by becoming a NT member (and if you can afford it, a life member). Visit their careers website for job opportunities. You may also wish to become a member of English Heritage, a government organisation that looks after a great many historic ruins and a few un-ruined houses. Their website has a jobs section, too. A surprising number of historic houses (usually the smaller ones) are owned by local authorities, often as part of larger museum services. The advantage here is that you may be able to get your foot in the door of one part of the service and then make a sideways move. That's how I got started, more or less by chance. There is no single website that you can visit for local authorities: you have to trawl Hudsons and the Museums & Galleries Yearbook, find out the name of the local authority concerned and locate its online vacancies bulletin. Some LA jobs are advertised on the Museums Association website, but not all.

Finally, there's the Historic Houses Association, the private owners' club. This, too, is a membership organisation which may be worth joining (membership gives free admission to the houses concerned). The HHA

has a vacancies section on its website. Often these 'private' houses are not exclusively private and have a trust involved or even a private company, which may own the building, all or part of the contents, or any combination of the above. If you go to work in one of them you may find yourself treated with the utmost courtesy and consideration – or as an upper servant, or worse. Be prepared for anything and hang on to your sense of humour!

Qualifications

A university degree in a relevant subject plus a postgraduate course in museum studies is now the standard requirement, but if you haven't got these things, apply anyway and be prepared to study for them on the job. (The Open University can be very helpful here.)

Finding a job

Lastly, there is the tricky question of what jobs to apply for. If you wait for advertisements which say 'curator' on the top line, you may be waiting a long time and it's worth considering a job in a related field, working for an organisation that employs curators or people who do curatorial work (who may actually be called something else). Employers are more democratic now than they used to be and it's possible, for instance, to move from a front-of-house role (security, interpretation, sometimes cleaning duties as well) into a curatorial position. But if you try this route and it's not getting you anywhere, don't wait and get stuck: make a move.

Above all – good luck!

FURTHER INFORMATION

Job advertisements
Museums Association
www.museumsassociation.org/careers/find-a-job

Historic Houses Association
www.hha.org.uk
There is a vacancies section on this website.

Organisations and directories
National Trust
www.nationaltrustjobs.org.uk

English Heritage
www.english-heritage.org.uk/about/jobs

Hudson's Directory
www.hudsons.co.uk

Museums & Galleries Yearbook
www.museumsassociation.org/publications/yearbook

Curator: Decorative Arts

Polly Putnam

Assistant Curator of Decorative Arts, Leeds Museums and Galleries

Being a curator of decorative arts is rewarding because the collections are so varied. The collections I look after at Leeds Museums and Galleries include 19th-century lino flooring, digitally made craft ceramics, and masterpieces of English silver. Understanding the decorative arts requires a solid understanding of art historical concerns of authorship, design sources and provenance, but also a grasp of an object's use and contexts. A desk, for instance, may have been made by Thomas Chippendale the Younger, but someone also sat at it and wrote letters or considered the affairs of the estate. Why did this particular person need such a desk? There are so many angles with which to consider decorative arts objects. For me the challenge comes in finding that single, headline-grabbing, piece of information that will enthuse members of the public.

One of the great things about being a curator of decorative arts is that it affords the opportunity to work not only in museums but also in country houses, town houses and castles. Looking after collections in such settings means that the curator there will not only need to know the collections but also to have knowledge of the history of the house, its interiors and the people who lived there. It adds another challenge but opens up the possibility of carrying out restoration work, which is exceptionally rewarding.

Career paths

Jobs in the decorative arts are few and far between. It is very rare to find curatorial roles specific to a subject specialism within the decorative arts, so be prepared to take on a general decorative arts role. At entry level remain quite flexible about the sort of jobs that you apply for. Any experience of museum work is good experience.

Many positions, especially at entry level, are on short-term contracts, so be prepared to be mobile. Full-time curatorial positions, particularly in historic houses, are often considered to be 'jobs for life', so opportunities are rare and are consequently highly sought after.

It is therefore of the utmost importance to make the most of any position that you have in order to progress up the career ladder. Be ready to do more than what is written in your job description!

Helpful Hints

A postgraduate degree is nearly always essential to gaining a curatorial position, even at entry level.

Think carefully about which one you choose. A vocational museum-based qualification will be especially useful, but a subject-specialist postgraduate degree may also be an advantage. There are very few specialist decorative art courses. (For details, see below.)

Volunteering is an essential process in becoming a Curator of Decorative Arts. It provides useful experience for your CV and offers insight into the way that organisations operate. Some postgraduate courses offer placements. I was very lucky to have had a year-long placement with the V&A as part of my Masters degree. Some institutions offer paid internships. These are often attached to a particular project, and it can look good on your CV to have worked to a defined outcome.

As stated, progression within the field is limited and competitive. It is important to make a name for yourself within your chosen field.

Be sure to join societies that relate to your field of interest; the lectures and trips they organise can expand your knowledge and provide a network of contacts.

Enrol in specialist courses. Participation in the Attingham Summer School is essential for pursuing a career in country houses. Consider doing the Associateship of the Museums Association (AMA) – anything to give you an edge over your competitors.

Contribute to society newsletters and (where possible) major journals. Give as many talks and papers as you can.

A solid publishing record is important to progress into a full-time permanent curatorial role.

65

FURTHER INFORMATION *see also after* Working in a Museum or Gallery: an Overview

Courses
History of Design Course at the V&A
www.vam.ac.uk/content/articles/m/ma-history-of-design

Sotheby's Institute Masters in Decorative Arts.
www.sothebysinstitute.com/Programmes/PLondon.aspx

Attingham Summer School
www.attinghamtrust.org/courses_summer_school.html

Organisations
Furniture History Society
www.furniturehistorysociety.org

The Society of Decorative Art Curators
http://sodac.org.uk

The English Ceramic Circle
www.englishceramiccircle.co.uk

The Silver Society
www.thesilversociety.org

Curator: Exhibitions

Sarah Brown

Leeds Art Gallery

The role of Curator of Exhibitions at Leeds Art Gallery broadly involves devising and delivering the temporary exhibition programme and its accompanying interpretation.

The temporary exhibition programme comprises four or five shows a year, including historic, contemporary, group and solo exhibitions. We work directly with artists, collectors and other institutions to initiate and partner on shows.

Leeds Art Gallery holds one of the most significant collections of modern British sculpture and is actively acquiring work by artists. Whilst I am very interested in the works of art in the permanent collection, the temporary exhibition programme can be made up of any media and reflects current artistic practices. Leeds Art Gallery has over 500,000 visitors a year, and exhibitions we devise must both appeal to this broad audience and introduce artists and works that have not been shown before in the region.

We are funded by Leeds City Council and are part of the City Development Department and the cultural portfolio. Whilst my position has a core budget, a significant part of my role involves raising funds from both public and private sources to enable new commissions, collections and publications that reflect current practice both curatorial and artistic.

Within Leeds Art Gallery I work closely with the curators responsible for the collections (Sculpture and Fine Art) and with conservators. Exhibitions always involve the technical and art handing team, so clear communication is essential, as is planning in advance and knowing artists' technical requirements for the installation of their work. My role involves developing ideas around the interpretation of exhibitions, and working closely with the Learning Team to devise workshops and events for families, to help them to enjoy their visit to the gallery, and to open up the exhibitions to wider audiences.

A compromise between idealism (the ambitions of contemporary artists) and pragmatism (the limitations of the architecture) informs exhibition making, but as a purpose-built gallery dating from 1888, Leeds Art Gallery also provides opportunities for artists to respond to the architecture and the gallery spaces.

Qualifications

Although some curatorial positions only require a BA, most museums and galleries require curators and exhibition organisers to have a master's degree specialising in an appropriate study for museums and galleries.

A good education, qualification and experience are key to the first steps of success in the curatorial museum and gallery profession. I have a BA History of Art (School of Oriental and African Studies, UCL) and an MA Museology (Sainsbury's Centre of Visual Arts, UEA), and I worked as a volunteer at Kettle's Yard House and Gallery for 12 months before my first paid position. Unfaltering commitment, luck and networking also help, as the job market, especially at entry level, is fiercely competitive.

If you are interested in historic or contemporary art, attending exhibitions regularly is vital, as is keeping abreast of critical press and specialised print. Reading periodicals, newspapers, and new media, and following key professionals on Twitter means that you are constantly updating your knowledge and not resting on your qualifications. Attending previews, artists' talks, seminars and symposiums, many of which are free or, if not, might welcome a voluntary assistant, is also a useful way of increasing your knowledge and of networking.

FURTHER INFORMATION *see also after* Working in a Museum or Gallery: an Overview

Graduate curatorial opportunities

The Contemporary Art Societies Starting Point Fellowship scheme www.contemporaryartsociety.org
This offers the chance to make an exhibition drawing upon collections and alongside curators who are experts in their field. Since 2012, Starting Point Fellowships have taken place at Southampton City Art Gallery, Leeds Art Gallery, and the Hunterian Museum and Art Gallery in Glasgow.

Arts Council Collection

www.artscouncilcollection.org
This offers exciting opportunities to devise and curate your own exhibition. Select.ac is a biannual curatorial competition directed at MA and PhD students in the UK, who are invited to apply to curate an exhibition from the Arts Council Collection. The context is the desire to extend access to the Arts Council Collection, and to encourage new approaches to exhibition making and new understanding of collections.

Axis

www.axis.org
The online resource runs curatorial competitions for young professionals, both curatorial and artists.

The Henry Moore Research Fellowships

www.henrymoore.org/hmi
These aim to encourage and support research projects in any area of sculpture studies. The Henry Moore Institute offers a small number of short-term residential fellowships to academic students.

Job advertisements

Art Web, The Artists Newsletter

www.artweb.com/artists-newsletter

Professional bodies

International Association of Curators of Contemporary Art www.iktsite.org

Commercial Gallerist

Andrew Stewart

108 Fine Art, Harrogate, Director

There are many routes available to anyone interested in working in an independent gallery, and in many ways it can be far easier to find a position in such a gallery than trying to pursue a career in the museum/public art gallery world.

My own background started with a four-year diploma in Drawing and Painting, followed by a two-year postgraduate course in the conservation of paintings. The following 15 years were spent working in museums and galleries, as both conservator and curator, before working at Bonhams Auctioneers as head of a picture department. Whether working as a porter or as a trainee, a good auction house is without doubt one of the best ways for graduates to acquire specialist knowledge, and business and marketing skills that will be extremely useful in most areas of the art world.

108 Fine Art was established in the late 1990s, focusing on the work of newly graduated artists. This quickly extended to the exhibition of works by more established artists, and in the next few years exhibitions by Ana Maria Pacheco, Norman Adams, Maurice Cockrill, Alan Davie, and Joash Woodrow were held in our Harrogate Gallery. Today, our business also includes running a busy paintings conservation studio.

108 Fine Art prefers to work with a relatively small group of artists, which allows more time to focus on each artist. As well as holding exhibitions at the gallery and through Art Fairs, we look to arrange public art gallery exhibitions for our artists, producing books and other publications to raise awareness of their work. Artists are also from time to time commissioned by the gallery to produce new work. Next year, 108 will move to larger premises in Harrogate, allowing us to expand our programme to include performance and film.

Working in a small gallery demands being involved with all aspects of running the operation, including general maintenance of the gallery, paperwork, planning, photography, design of catalogues, website, newsletters, conservation, framing, preparing exhibitions, hanging, transport, attending art fairs, liaising with artists, liaising with clients, executing sales and purchases.

As an independent gallery we do not seek or receive any public funding.

The perks of working in a private gallery are many. Every day is different, and routines change constantly. The facility to work with great artistic talents is an immense privilege, and the anticipation of discovering a new artist with a unique vision could not be more rewarding. As with most jobs, much of the day involves the steady grind of humdrum business, but this will always be outweighed by the freedom that comes with working in a small independent business.

Main benefits of the job:

♦ The privilege of working with talented, creative individuals who share a common passion
♦ Sharing interests with collectors and the public
♦ The excitement of seeing inspirational new work for the first time
♦ The flexibility and freedom of choice in 'what happens next'.

Drawbacks:
♦ Bureaucracy
♦ Not enough hours in the day.

FURTHER INFORMATION *see after* **Working in a Museum or Gallery: an Overview** *and* **Conservation: an Overview**

Educator: National Museums

Gill Hart

Head of Adult Learning at National Gallery London

Museum and Gallery Education is a wide-ranging field, varying greatly depending on whether seen within a National, Local Authority, Independent or University context. In many smaller organisations there may only be one education officer, responsible for all aspects of public engagement. (In very small organisations there may be none at all, and the public-facing work is shared out across other staff members or volunteers.)

Where education departments do exist, there are sub-categories or specialisms, such as pre-school, schools, families, young people, community, outreach, access, students, and adults. The larger the organisation, the more likely it is that education departments will have allocated roles or teams to these specialisms.

I studied History of Art at Edinburgh University, where we were encouraged to use the collections of the National Galleries of Scotland as our primary resource and often had to stand in the galleries, delivering talks to our fellow students (and passing members of the public). I knew from my first year that this is what I wanted to do as a career – communicate ideas and generate debate about paintings. I was always particularly interested in exploring the possibilities of enhancing the experience of looking at paintings for non-specialist adult visitors.

My first job in gallery education was as an Education Officer at the National Gallery. This post requires a lot of public speaking to various interest groups. A working day might involve leading a guided tour for sightseers, researching a lunchtime lecture, or preparing a course on a specific period of art. Occasionally it requires stepping in when another speaker is suddenly unavailable. I often found myself teaching Greek myths to school groups or talking to university students about theories of the picturesque and the sublime. One thing to be prepared for in an education role are the daily surprises!

In the 12 years since I began working in gallery education, the work that we do has become more discursive and participatory. The more traditional models of delivering adult learning programmes are still in place (and there is still a strong thirst for them), however they now sit alongside more conversation-driven models of practice.

Although often still described as 'education', this area of museum and gallery work is now known as many other things: learning, participation, community work, inclusion, access, public programmes, and engagement. The educational or learning function of a cultural organisation is not solely understood as meaning working with children and schools, and it is not always based on a curriculum or achieving specific learning objectives. Many departments have dropped the word 'education' from their titles entirely. Whilst I spend much of my time ensuring that the National Gallery provides a wide spectrum of learning opportunities for visitors – ranging from interactive and hands on through to discursive and academic – I spend just as much time planning for the moments when people can come into the gallery and get involved with something that involves socialising and enjoyment.

What does Museum and Gallery Education involve?

In organisations where education and learning staff actively deliver the programmes they manage, the ability to teach, or a clear understanding of teaching, and of different learning styles, is a prerequisite. Some organisations book freelance educators to deliver their programme, and if engaging with the public is what fires you with enthusiasm, then you may consider pursuing this path, perhaps gaining initial experience through work-placements.

There are other creative aspects to the role of museum and gallery educator, ranging from liaising with artists and

writing marketing copy to project design and curating public programmes.

Education departments are lively communication hubs. As public-facing departments within public-facing organisations, the phones are usually busy and email traffic is often heavy. Swift and efficient communication is essential. Education administrators, officers and managers usually have a fair amount of administration to attend to on any given day – from sending out letters of confirmation for a group visit or contract letters to visiting speakers, through to booking catering, compiling evaluation reports and event management.

Career path

There are several different routes into this area of expertise. Many Museum and Gallery Educators have undergraduate degrees in a humanities subject (not always History of Art) and go on to obtain postgraduate degrees either in Education (and are therefore qualified teachers) or in a chosen area of History of Art. Another common route into Museum and Gallery Education is to obtain a Masters in Museum Studies – a course consisting of modules covering different areas of organisational activity, including education.

FURVER INFORMATION *see also after* Working in a Museum or Gallery: an Overview

Jobs advertisements
Arts Council
To find your regional offices visit
Arts Council England www.artscouncil.org.uk
Arts Council Wales www.artswales.org.uk
Art Council Scotland www.scottisharts.org.uk
Information and research, job listings and professional development.

Arts Professional
PO Box 1010, Histon, Cambridge CB24 9WH
t: 01223 200200
e: webmaster@artsprofessional.co.uk
w: www.artsprofessional.co.uk
Information, professional development, research and job listings.

The Guardian – online job listings currently in the Monday and Saturday print editions.
w: www.jobs.guardian.co.uk

a-n The Artists Information Company
The Toffee Factory S19, Lower Steenbergs Yard
Quayside, Ouseburn, Newcastle upon Tyne NE1 2DF
e: info@a-n.co.uk
w: www.a-n.co.uk
Information, career support, research and job listings for subscribers only.

engage
Rich Mix, 35–47 Bethnal Green Road, London E1 6LA
t: 020 7729 5858
e: info@engage.org
w: www.engage.org
A membership organisation representing galley, art and education professionals in the UK and worldwide, providing information, research, resources, job listings and professional development for subscribers only.

Professional development
Group for Education in Museums (GEM)
54 Balmoral Road, Gillingham, Kent ME7 4PG
t: 01634 853424
e: office@gem.org.uk
w: www.gem.org.uk
Information, professional development, resources, volunteer opportunities.

The Council for Learning Outside the Classroom
www.lotc.org.uk
Information, research and training

Yorkshire Sculpture Park West Bretton, Wakefield, West Yorkshire WF4 4LG
t: 01924 832631
e: info@ysp.co.uk
w: www.ysp.co.uk
Information, research, resources, volunteer placement and job opportunities.

Educator: Local Museums

Janette Pratt

Head of Learning, Yorkshire Sculpture Park (YSP)

It is generally acknowledged that the most important qualities a person needs in the field of arts education is a passion for making art accessible to all, a deep understanding of the creative process, and an interest in the multitude of ways people learn and enjoy the world around them. This sits alongside a motivation to open doors for those who may need a helping hand, and a will to investigate the many layers of society that shape how people live around the world.

Learning teams in an art gallery and museum aim to make art, and in the case of the Yorkshire Sculpture Park the landscape, accessible to the whole community, and to offer opportunities for people to engage with the arts in a creative and meaningful way.

Job profile

The Yorkshire Sculpture Park (YSP) is an international centre for modern and contemporary art set in 500 acres of historic parkland, with five indoor galleries, open air displays, and a dedicated Centre for Learning. Over 380,000 people visit each year, with 47,000 people engaging in learning activities.

The core purpose of the Learning Team is the creation of an innovative and thriving programme, which underpins all YSP activities. Exploring the issues of art, heritage and the environment, we reach out to a wide variety of audiences, from nursery to third-age learners, and to people of all abilities and backgrounds. This includes families, formal and informal educationalists, volunteers and people on work placements, adult learners and communities.

The outreach programme reaches beyond our physical boundaries and in doing so we hope it makes a positive contribution to the wider community. The outreach work comprises long-term projects that focus on three themes: arts and criminal lustice (exploring art with young offenders, prisoners and young victims of crime), ethnic and social diversity (projects investigating global cultures and creating accessibility to art for communities in areas of deprivation) and health and wellbeing (creating art and discussion with older people with dementia and for people with mental health issues, also supporting physical fitness through, for example, the Walking for Health national initiative).

Members of the Learning Team might find themselves working closely with schools, colleges and universities to explore the links between the curriculum and the arts, utilising creative learning methods. This may include the delivery of hands-on workshops and tours, and developing teaching resources that encourage teaching staff to embed new skills within their teaching practice.

Developing unique events for the general public and for targeted audiences such as family or adults is an interesting aspect of the role. Each event offers a new area of research and delivery, working with artists to interpret the exhibitions, heritage and environment of the gallery and museum. A fulfilling journey can be undertaken through long-term projects with hard-to-reach audiences, where a close working relationship which engenders trust between the participants and museum creates bespoke and responsive projects.

As Head of Learning I work closely with curatorial, marketing, visitor information and other teams, to develop and implement the public-engagement programme. This includes raising funds with the Development Team, and devising company strategies, policies and business plans. An important element of my role is to maintain a national presence within the profession, and to represent the Sculpture Park where appropriate, on local, national and international platforms. This may include contributing to professional bodies such as engage, the Arts Council, and local authority advisory services.

Qualifications

Graduates in Art History have attained a valuable body of knowledge which can provide the foundation for this area of work. Qualifications accepted in this sector are a BA in fine art or related subject (as a minimum); it is common for people to hold an MA with an arts/gallery/education/environment focus. Postgraduate qualifications in cultural management are also beneficial. In the United Kingdom this is a low-waged sector.

Skills required and gaining experience

Volunteering with many different organisations provides an invaluable insight and understanding of the sector, and often leads to employment. Placements offer similar benefits. Working as a freelance arts education practitioner is useful in helping you gain the required breadth of knowledge and experience. Freelance project coordination is also a recognised path to more permanent full-time roles.

It is essential to gain experience in working with people of all ages, backgrounds and abilities. This includes working in a variety of settings such as formal and informal education, health care, criminal justice, and social and economic support services in local authorities. The skills that are needed for project coordination include marketing, writing, fundraising, evaluation, documentation and design. In programme management, the additional skills of finance, and the training/management of staff, placements and volunteers are required.

Establishing a body of quality work, creating workshops, events, projects, exhibitions and initiatives with a broad range of people and organisations is necessary when seeking employment or funding. A professional approach to administration, an ability to communicate well, and flexible working methods are key skills that can be built upon as work experience grows – from volunteering to leading large-scale programmes of work.

It is also important to keep abreast of comparable work in museums, galleries and arts organisations, as well as new developments in education, government policy and relevant areas of research.

FURTHER INFORMATION *see after previous article, and also after*
Working in a Museum or Gallery: an Overview

Events Manager

Natasha Halford

Head of Events, The National Gallery

As Head of Events at the National Gallery I lead a four-person in-house team in the planning and execution of private gallery events, including exhibition openings and sponsor functions, and in the delivery of the corporate events that form part of the gallery's Corporate Membership scheme. Our job is twofold: we are event planners and are also responsible for ensuring that both our clients and our contractors adhere to the building's strict regulations and operate with respect and care within the walls of this national treasure.

Having realised that the curatorial path wasn't right for me, I set about exploring the extraordinarily different career paths of the museum world. The online organograms didn't really make sense. Who are 'Registrars'? What happens in 'Development'? I busily focused on work-experience placements during my school and university summer holidays, including stints at Christie's and at a private art consultancy. Both were fantastic learning opportunities and I would heartily recommend exploring work experience in local art institutions or private galleries to get a flavour of the options out there.

On leaving Bristol University with a degree in History of Art, I worked by day at the private art consultancy, and by night at Tate Modern, helping to run its public lectures. The contacts and the network I began to build up at Tate put me in a good position when a job opened up in the Corporate Events Team. After five years I moved to the Imperial War Museum to run the events team there for two years, after which I moved to my current role at the National Gallery, I've now been here for five years.

Museums are wonderful places to work in: full of people who are deeply committed to their area of specialty, and who want to help each other get their jobs done. The fantastic thing about being in the events team is that we work closely with a huge variety of departments, the porters, the art handlers, the cleaners, the security team, the Director and the trustees. In order to achieve successful events we have to work well with everyone and we love this element of our role.

The events team also has to react quickly and decisively when problems occur. The National Gallery sits in the middle of a high-security zone in Westminster and we often have to be creative when balancing civil unrest in Trafalgar Square (such as kettled students), and client expectation. Most of my family think I spend my day choosing canapés, but it really couldn't be further from the truth!

The events team sits within the wider development department, the primary role of which is to fundraise for the National Gallery, through corporate, private or trust support. In these difficult economic times, support like this is essential for the National Gallery to continue its work, and our funders contribute to a myriad of activities, from special exhibitions to education projects. The events team supports development by creating entertainment opportunities for current and potential supporters, working closely with the fundraisers to hit the right tone and balance.

When recruiting for our department the principal thing I am looking for is experience, either from a similar organisation or one from which skills are transferable. That is why work experience or starting at administrator level is so important. I may not be popular for saying so, but events management courses don't match practical on-the-job experience, although they can give you interesting tools.

I have loved working in three astonishing institutions over the past 12 years. It is a fascinating sector to be a part of and no day is ever the same. The variety comes from the exhibitions, the challenges, but also the people: I have

met some extraordinary individuals along the way, although I still haven't mastered my poker face. I memorably bobbed a curtsey for a good five minutes on meeting Prince Charles a couple of years ago and I can't promise I wouldn't do the same thing again!

FURTHER INFORMATION *see also after* **Working in a Museum or Gallery: an Overview**

Job opportunities
The Guardian online
http://jobs.guardian.co.uk

National Museums Directors' Council
www.nationalmuseums.org.uk/jobs

Unique Venues London
www.uniquevenuesoflondon.co.uk/vacancies/index.html

And, if you want to work at a specific institution, check their website regularly for job opportunities.

Museum Registrar

Jen Kaines

Registrar, Leeds Museums and Galleries

The history of museum registration and the role of a registrar is a relatively recent one. Depending on the size of the institution and the scale of its operation there may be one or many registrars. Many museums will operate without an official registrar, but the tasks carried out are fundamental to the effective running of any museum or gallery.

So what is a 'museum registrar'? There is no quick and easy way to define the job. It has been variously referred to as 'the museum's conscience', as a 'travel agent for objects', and as logistics manager, risk manager, and facilitator. In the UK a registrar registers births, deaths and marriages of people, and a museum registrar generally carries out the equivalent functions for objects.

With national and international legislation and the risk of litigation having an ever-increasing impact on museums and galleries, the role of registrar is becoming more important.

The role can differ greatly between organisations, but there is a set of discrete skills registrars must develop. They need to ensure that they are aware of the legal and ethical issues relating to their individual collections and its use, and best-practice in collections management. And they need to develop a flexible approach to working, in order to ensure that they protect the collections, institution and themselves from risk.

A registrar will need skills and specialist knowledge in:

♦ ethics and industry standards

♦ cultural heritage law

♦ law as it relates to collections

♦ security of collections

♦ audit and risk management

♦ policy and legal document writing

♦ principles of collections management

♦ acquisition and due diligence

♦ loans management, law and logistics.

There is no standard day in the life of a registrar. Although many activities are similar, because of the nature of objects and collections there will be differences and individual problems that make the job always interesting and exciting.

There are groups for registrars, and museum registrars in the UK, USA and throughout much of Europe. The UK Registrars Group aims to establish, promote and support standards, and is a good forum for exchanging ideas and expertise.

Qualifications

There are currently no formal qualifications for registrars. Most posts require a Masters degree in museum studies or equivalent, and experience. Many registrar departments will take trainees, interns and volunteers. There are a few paid traineeships, but most are on a voluntary basis. Registrars mostly learn on the job, or from each other. This is an organic process that inherently involves risk, given the nature of the role. There is a move to formalise the training, but this is still at an early stage in the UK.

FURTHER INFORMATION *see also after* **Working in a Museum or Gallery: an Overview**

UK Registrars Group
www.ukregistrarsgroup.org

Retail

Graham Bancroft

Heritage Retailing Consultant

Funding sources for art galleries, museums and heritage attractions are generally becoming increasingly difficult to access. A consequence of this is that such venues are taking steps to increase their own 'self-generated' funding streams. A key element to this process is often the establishment of a profitable shop and/or on-line trading operation.

Even venues that struggle to actually generate retail profits are seeing the value of a good on-site shop. For many people, shopping is now a leisure activity in itself and a good, themed, retail unit can add considerably to the enjoyment of a visit to a cultural venue. The shop is often a key contact point between visitors and staff, and gives the venue staff opportunities to engage with customers and help encourage a return visit.

Careers in Retail within Museums and Galleries generally split into three categories.

Shop sales

At an 'entry-level' position, there are often opportunities to work part-time or full-time at the sales point(s). Employers will usually look for some retail experience, but relevant academic qualifications can help considerably, especially if it means that sales staff can converse accurately with customers about the inspiration and sources for individual products.

Whilst acknowledging the value of an academic background, most employers will be looking for:

- an ability to communicate with customers from all backgrounds
- a smart tidy appearance and outgoing disposition
- ability to work unsupervised at times and to use your initiative to increase sales (i.e. cleaning, tidying etc)
- a trustworthy attitude to handling money and products.

A creative talent that can be used for shop displays is often a bonus to potential employers. Employers are increasingly looking for 'sales' staff to boost income, not 'cashiers' to passively handle cash.

In general, a suitable personality and some retail experience is often more important than academic qualifications. However, for career-minded students looking to progress in cultural venues, a starting role in retail can provide the basis to prove a wider commitment and ambition to progress into other areas of the museum or gallery. In other words, it can be a good 'stepping stone' to other positions.

Remuneration varies, largely depending on the size and structure of the organisation and location. However, the hourly rates offered would probably start just above a standard minimum wage.

Retail Supervisor/Manager

For those people who have worked in retail and enjoyed the experience, there are opportunities to move to a more senior management level. Added responsibilities might include the following:

- opening and closing the shop and managing all staff rotas
- handling payment types and accounting for financial transactions
- motivating and training staff
- controlling stock, including annual physical checks
- maintaining the cash register system
- displaying stock effectively within the shop.

In the majority of venues, the role is also likely to include sourcing and procuring all the stock. This can be a particularly enjoyable process, possibly utilising relevant academic knowledge allied to a commercial aptitude. Stock sourcing usually involves attending trade fairs and meeting representatives, as well as developing bespoke ranges from archive material.

Again, experience outweighs academic qualifications in most job opportunities, but a relevant background knowledge allied to a commercial approach is always likely to be valuable. Salary levels are highly dependent on the income potential of the shop and can vary from around £15K to £50K at some major sites.

Product Buyer

In particularly large venues, or those with a high retail income potential, the stock sourcing and buying role might be separated from the day-to-day responsibilities of the Retail Manager. Such a role might take the form of a commercial manager, or more likely product buyer.

In the role of buyer, a relevant academic qualification allied to the theme of the venue could be particularly useful. However, employers will be looking for buyers who can distinguish relevant, themed, profitable products from product ranges that simply reflect the buyer's own personal taste!

Such roles are usually only available in large organisations, but they can be very rewarding, both in terms of job satisfaction and in their contribution to the upkeep of the venue. Salaries will be similar to those offered to retail managers, but a successful buyer could look for career progression into other commercial areas (such as product licensing) at major national institutions.

FURTHER INFORMATION *see also after* Working in a Museum or Gallery: an Overview

Museums Association
wwwmuseumsassociation.com

Association for Cultural Enterprises
www.acenterprises.org.uk

English Heritage
www.english-heritage.org.uk

The websites of museums and galleries you are interested in working in.

Post-Doctoral Funding Opportunities

Matt Lodder

Association of Art Historians

The route to permanent, full-time academic employment following the completion of one's doctoral studies now often involves one or more periods of fixed-term post-doctoral work, and it is becoming increasingly important for early-career candidates to have undertaken a specific, third-party funded, post-doctoral project to ensure they are competitive when applying for lectureship positions.

There are three routes into a post-doctoral position. The first, which is increasingly common, is to work on an established, pre-funded project. The AHRC and other funding bodies now distribute funding to universities in block grants, and senior staff will often specify post-doctoral positions as part of their initial funding bids. As such, it may well be possible to insert yourself as a named post-doctoral researcher during the initial bid stage, which will require you to have made good connections within the discipline and to have strong working relationships with several departments such that when these bids are being put together, you are able to put yourself forward to add your expertise to the bid. Alternatively, if a funded project has been allocated a post-doctoral position but with no specific name attached at the bid stage, the post will be advertised (on jobs.ac.uk) and you will be able to apply in the way you would any other job. These posts are fixed-term (anything from a few months to five years), and often only part-time.

The second is by proposing an individual project to a funding body such as the British Academy as part of a fellowship or research grant scheme. Post-doctoral fellowships (short-term roles usually combining research and teaching, see next entry) and research grants (sums of money provided for the completion of a specific project) both depend on institutional support, and applications usually need to be made with direct co-operation from – or in some cases actually submitted via – higher education institutions (HEIs). Funders in general prefer post-doctoral projects to take place in an institution other than that where the applicant's doctoral work was undertaken, and it is strongly recommended that applicants begin building relationships with potential future hosts as early as possible. External thesis examiners are often the most compelling people to approach in the first instance, as they will be familiar with the candidate's research, likely involved in a department or centre whose work and specialisms match the candidate's own, and often already somewhat committed to and interested in the candidate's career progression.

The third is to take up an advertised fellowship at a specific university, museum or research institution. University fellowships vary, and can be institution-wide or specific to a discipline or department. Most departmental fellowships will combine a fairly heavy teaching load with some research (despite being advertised as 'Teaching Fellowship' or 'Research Fellowship'), and will usually involve covering for a permanent member of staff who is on research leave. Museum and research institution fellowships are usually narrowly targeted to the specific concerns or collections of the specific host.

FURTHER INFORMATION

Researchresearch.com
A useful tool for keeping track of opportunities as they arise.

Jobs.ac.uk
Most departmentally hosted positions will be advertised here.

Specific schemes

The schemes listed below are by no means exhaustive, and the information is provided as a starting point for your own research. The terms and conditions, application periods, eligibility criteria and general remits of all these schemes can vary from year to year, so it is imperative that prospective applicants obtain up-to-date information from the organisations' websites before considering their applications.

Leverhulme Trust Early Career Fellowship
www.leverhulme.ac.uk
Funds applicants in any discipline.

To be eligible, you must be within three years from the date of your PhD viva. The proposal must be for a substantial piece of new research (different from your doctoral thesis) for completion over the course of the fellowship. Applications will be judged on a number of factors, including "the scholarly importance of the project, the ability of the applicant to carry out the research successfully, the feasibility of the proposed research programme, especially the proposed methodology and timescale, and the applicant's publication record to date, bearing in mind the early-career focus of the award".

The fellowships are currently for three years. The Trust pays 50 percent of the costs of hiring the Fellow, with the HEI funding the remainder. At the time of writing, an additional £6,000 per annum is available on top of salary to fund research expenses such as travel. Fellows will be expected to focus almost exclusively on research.

The deadline for the scheme is in March each year, but applicants will usually need to go through an internal selection process at their chosen host institution first. Applicants are encouraged to begin approaching potential hosts as early as September prior to the March deadline.

The Leverhulme ECF attracts around 700 applicants per year, and funds about 75 projects in total across all disciplines.

British Academy Postdoctoral Fellowship
www.britac.ac.uk
Remit covers work in the arts and humanities.

Fully funded three-year fellowship, for a substantial piece of new research for completion over the course of the fellowship. Because it is fully funded, it is more flexible in terms of host institution than the Leverhulme. In addition to the Fellow's salary, it pays an additional £2,000 per annum in research expenses. An initial project proposal is to be submitted in October. If successful in the first round, you will be invited to submit a fuller, more detailed proposal, with a deadline in March. As with the Leverhulme, applicants are encouraged to begin discussions with potential host institutions as early as possible.

The British Academy receives 900 to 1,000 applications per annum, with 120 invited to the second stage, and 45 fellowships offered.

Paul Mellon Postdoctoral Fellowship
The Paul Mellon Centre for Studies in British Art
www.paul-mellon-centre.ac.uk

Open to scholars of British Art and Architecture within four years of their PhD. It is a short-term block of funding (six months) designed to facilitate the conversion of the thesis into a book, series of articles, or exhibition catalogue. The current award stands at £8,000 for the six-month period, payable to either a host institution or to the scholar directly if they are unaffiliated.

Wellcome Trust Research Fellowships in the Medical Humanities
www.wellcome.ac.uk/Funding/Medical-history-and-humanities

If your work has aspects that intersect with the history of medicine in any way, you might be eligible for funding from the Wellcome Trust, who fund projects of up to three years' duration. There is no set application period, and preliminary proposals are accepted throughout the year. Applicants must include a letter of support from a host institution when submitting their primary proposal.

Individual universities/departments

Opportunities may be posted on a project-by-project basis. There are several recurring post-doc positions funded by endowments, which include:

Junior Research Fellowships (JRFs)
Three- or four-year projects, often at Oxford or Cambridge. Applicants are encouraged to apply during the last year of their PhD, with an application deadline in August. (See next entry.)

Terra Foundation for American Art Postdoctoral Teaching Fellowship
Two-year research and teaching fellowship at The Courtauld Institute for work on American art prior to 1980. Deadline in January.

Andrew Mellon Foundation MA Postdoctoral Fellowship
One-year research and admin fellowship at The Courtauld Institute. For Courtauld PhD students only.

International opportunities
There are postdoctoral opportunities all over the world, many of which will be open to international applicants. ResearchResearch.com will give a good overview, and the list below is only a summary:

AHRC International Placement Schemes
www.ahrc.ac.uk/Funding-Opportunities/Pages/InternationalPlacementScheme.aspx

Marie Curie Individual Fellowships
http://ec.europa.eu/research/mariecurieactions

ERC (Starting Grants)
http://erc.europa.eu/starting-grants

Terra Fellowships in American Art
www.terraamericanart.org/scholarship/fellowships

Postdoctoral Research Fellowships

Hannah Williams

Junior Research Fellow in Art History, St John's College, University of Oxford

Postdoctoral fellowships can be an invaluable stage on the way to a permanent academic research or teaching position, even though they are not a career in themselves. They usually last between one and three years and are awarded to early-career researchers immediately after completion of the PhD or within a limited number of years after submission (usually between three and five but this varies according to the specifications of the fellowship). Most fellowships are funded or part-funded by an external research body (e.g. the British Academy, the Leverhulme Trust, or the Arts and Humanities Research Council (AHRC)), and successful candidates then take up a position in a university department that has agreed to act as the host institution. Some universities, departments and museums also have their own fully funded fellowships. For example, some Oxford and Cambridge colleges offer Junior Research Fellowships in various subjects; the Yale Center for British Art has Postdoctoral Research Associate positions for those working on British art from any period; and the Center for Advanced Study in the Visual Arts (CASVA) at the National Gallery of Art in Washington has both pre- and postdoctoral fellowship programmes.

What does it involve?

In terms of a job description, postdoctoral fellowships can vary depending on several factors (e.g. the institution, the length of tenure, the funding contingencies, etc), but the general principle behind them is the same. These positions are intended to offer an early-career researcher the opportunity to pursue their research, usually by embarking on a new postdoctoral project, or sometimes by extending the doctoral project. The research areas of postdoctoral fellowships can either be open or quite specific: for some positions, candidates formulate and propose an original topic that they wish to pursue; for others, the topic is already defined (under a larger funded project being collaboratively worked) and an appropriate candidate sought, based on corresponding research interests and experience. Some fellowships also have teaching and administration requirements (these are usually minimal as the emphasis in these positions is on research).

Why would you want one?

A postdoctoral research fellowship offers valuable opportunities to advance an academic career. It provides young scholars with the chance to pursue research without the immediate time pressures that come with a full-time teaching position, thus allowing early career academics to revise doctoral research for publication, to develop new research projects, and to communicate research findings in conference papers and other scholarly presentations. These publications and research outputs can help considerably when applying for permanent academic positions. So if you are keen to pursue a career in academic research (primarily in universities but also in museums) it's a great thing to do.

How do you get one?

Postdoctoral research fellowships are limited in number so the process can be very competitive. Your application needs to have a clear research project that you want to pursue, and a strong CV in terms of academic activities (conference papers, organising symposia, etc) and, if possible, publications. In some cases (particularly those fellowships administered by external funding bodies) you may also need to approach an academic or department to support your application. After the initial applications round, shortlisted candidates are then usually invited to a formal interview.

FURTHER INFORMATION

Fellowship advertisements
www.jobs.ac.uk

Association of Art Historians – Jobs & Opportunities
www.aah.org.uk/jobs

College Art Association – Career Center
careercenter.collegeart.org/jobs

Times Higher Education Supplement
www.timeshighereducation.co.uk

External Research Funding Bodies
British Academy
www.britac.ac.uk

The Leverhulme Trust
www.leverhulme.ac.uk

Arts and Humanities Research Council (AHRC)
www.ahrc.ac.uk

Institutions offering postdoctoral fellowships
The Getty Foundation
www.getty.edu/foundation

The Paul Mellon Centre for Studies in British Art
www.paul-mellon-centre.ac.uk

Smithsonian American Art Museum
The Terra Foundation Fellowships
www.AmericanArt.si.edu/fellowships

Durham University
www.dur.ac.uk/ias/diferens/junior/

Oxford University, individual colleges, and British Academy
Postdoctoral Fellowships
www.humanities.ox.ac.uk

Cambridge University, individual colleges, and Centre for
Research in the Arts, Social Sciences and Humanities
www.crassh.cam.ac.uk

Marketing Yourself Effectively

Christina Bradstreet

Director of Career Services

Sotheby's Institute of Art London

When applying for jobs in the art world it is important to market yourself effectively. Good language skills and experience in the arts will help convince an employer that you are well qualified and competent. However, the sheer number of candidates applying for positions (from the lowly internship to the most senior directorship) means that your CV/resume will only be shortlisted if it is immaculately presented, successfully articulates your achievements, and is targeted to the needs of the employer.

The power of self-marketing is so great that a less experienced candidate can often successfully capture the employer's interest if they demonstrate a genuine and well-thought-through interest in the role and the organisation, and have clearly put more effort into the application and interview preparation than any other candidate. You will always be competing against a large number of highly qualified and experienced candidates, but if you go the extra mile with your application, you really can stand out from the crowd.

Job hunting takes dedication. You will need not only to research the employer and the role advertised, but also assess your personal selling points – the skills, experiences and interests that make you a unique employment prospect – and work out how best to articulate them. Doing so should give you an inner glow of confidence that will stand you in good stead during the interview.

Why should they interview you?

You are a professional working in the arts sector and your application must reflect this. Invest time and effort into thinking about how you want to present yourself and create a world-class CV/resume.

A resume is an individual document that must communicate succinctly who you are and what you have achieved. Whilst it is all about you, it must convince the employer that you have the particular skills and accomplishments that he or she specifically requires for the job in hand. Since first impressions count, you must quickly create a positive, lasting impression. Most employers spend less than a minute reviewing a CV/resume, so it needs to be a powerful communication tool. It must look good and communicate clearly.

Remember there is no one solution – only what works best to communicate your individual strengths and experiences as they relate to the individual employer's needs. You can refer to the countless samples in CV/resume books online, in bookstores and libraries, and you can obtain feedback from friends and colleagues. Ultimately, however, you must find the best format and presentation that works for you.

Creating a killer CV/resume

The purpose of a CV/resume

From your perspective it needs to:

♦ communicate succinctly your professional and educational experience

♦ enable prospective employers to assess your suitability

♦ be skim-read along with hundreds of others

♦ survive the screening process after a cursory glance

♦ get the employer interested

♦ convince the employer they should interview you.

From the employer's perspective it needs to:

♦ screen out as many candidates as possible after a cursory glance or two

♦ help find a small number of candidates worth interviewing.

You will need to tailor your CV to fit the job. By all means create template CVs/resumes for the different types of jobs you are going for, such as work in galleries, auction

houses, or educational institutions. However, these must always be reworked and tailored for each and every specific position you apply for.

To do this you will need to do extensive research, focusing on three main areas:

♦ the company

♦ the role

♦ yourself.

The company
Study the organisation and the director carefully. Find out as much as possible by reading the company website and any reports, brochures or other documents they produce. Also undertake internet and newspaper research and speak to employees and others. Put yourself in the employer's shoes and think about what they are looking for.

The role
Study the job description carefully. If a full job description has not been provided, use job descriptions for similar roles to help you demonstrate that you have experience of all the key tasks involved (or as many as possible). If, for example, the job is an art gallery registrar, but little information is given about the role, be sure to research what the typical tasks of being a registrar involves, and how these are usually phrased.

♦ Search www.prospects.ac.uk for standard job descriptions.

♦ Keep a file of job descriptions of interest, to help you when applying in the future.

♦ Consult some of the many books available.

♦ Remember to save a copy of the job description. After the deadline has passed it may be taken off the company website and you will need it for your interview preparation.

Yourself
A CV/Resume is less about presenting the story of your life, and more about showing a particular employer that you have the skills, experiences and qualities they are seeking for this particular role. So now that you have found out, as best you can, what they are looking for, you need to brainstorm exactly how you are a good match for them. Then you can be sure to emphasise the things that are of most interest to the employer.

Only when you have undertaken thorough research can you present the employer with an image of yourself tailored to their individual needs and expectations.

Making the most of your skills and experience
Highlight the match. Make it easy for the employer to spot a potential match between you and the job. Demonstrate that you have as many as possible of the attributes listed in the specification by describing activities or tasks you have undertaken that display these. If you have never done the same tasks, list those you have done that are most similar.

Employers need quickly to determine how your experience will benefit them, so, like an advertisement in a newspaper, your CV/resume needs to be full of benefits relevant to the reader.

Presenting your CV/resume
Content
♦ Ensure that it is easy to read *at a glance*.

♦ It should be either one or two complete pages.

♦ Consider the language you use very carefully. The fewer words, the better. Ask yourself 'How can I say this more simply?'

♦ Avoid paragraphs of text. Ask yourself whether the information would be better placed in your covering letter.

♦ Arrange the information in easily digestible chunks – using bullets rather than paragraphs to describe your responsibilities and achievements.

Design
♦ Leave space between the elements.

♦ Use clear headings.

♦ Use neat, consistent formatting, with tabs or, better still once you've mastered it, a table with no borders.

♦ Although it should be simple and elegant, don't make it too bland. Ask a friend to help you if you are not good at design.

♦ Avoid overly arty CVs and anything zany, such as photos, rainbow colours or lots of different fonts or sizes within the text.

♦ Avoid underlining, but make use of bold or italic.

♦ You can use slightly larger font sizes for headings, but avoid using this for emphasis within your text.

♦ Your choice of font will, inevitably, convey something about you, so, again, ask a range of people for their impression of the finished CV/resume.

♦ For headings, you might consider a font that contrasts with the text you use for the body text, but it may be better to stick to a single, carefully chosen, font.

Structure

Personal details:

♦ Your name and contact details can be made to form an attractive heading.

♦ Never put Curriculum Vitae or Resume as your title.

♦ Don't include your date of birth or marital status.

Profile (US) or Personal Statement (UK):

This is a *short* powerful statement (three sentences maximum) at the top of the resume enticing the reader to read on. Focus on who you are and what you have to offer, rather than what you are seeking to gain.

Education:

♦ Education or experience first? If you have undertaken substantial paid employment *in the arts,* list experience first; otherwise education.

♦ List most recent education/experience first.

Undergraduate education:

♦ Keep it succinct. Don't let it dominate your resume.

♦ Give only key achievements, especially those relating to the arts or business.

Secondary school:

♦ Postgraduates would probably do best to limit this to the institutional name, A and AS levels and grades. Undergraduates might also wish to summarise the number of GCSEs and grades they achieved.

Experience:

♦ Put most recent first.

♦ Describe your responsibilities concisely, giving priority to those most relevant to the job you are applying for.

♦ Professional non-arts experience – write this in a way that arts people understand.

♦ Part-time jobs, e.g. waitressing, sales, admin. Retain these, unless you have sufficient relevant professional experience. These demonstrate your employment history and transferable skills, such as communication and customer service.

♦ Give details of projects you have been involved in. How much money did you raise? How large was the budget? What efficiencies did you implement? How much money did that save? How many staff did you supervise? What initiatives did you introduce?

Optional sections:

♦ Professional skills such as special computer knowledge, languages etc.

♦ Professional affiliations related to art such as the Association of Art Historians, American Museums Association, Young Professionals in the Arts.

♦ Include any other achievements or voluntary service that doesn't fit under experience or education.

♦ When describing interests and achievements, avoid vague terms such as reading, travel, sport, theatre. Give specific achievements such as 'backpacked 100 miles across eastern China' or 'hockey captain for University of Warwick'.

♦ Interests should demonstrate transferable skills such as confidence- or team-building skills, or initiative or relevant specialist interest.

♦ It is not necessary to list references on the resume. The employer will ask for these when they need them. Only include references (maximum of two) if you would otherwise not have sufficient information to fill the page!

Tip: Swap your CV/resume with that of a classmate or friend and review each other's.

1. **First impressions. Look at the resume for one minute or less.**
 ♦ What stands out? What needs to stand out more?
 ♦ What does it communicate about the person?
 ♦ Is there anything that could be taken out?
 ♦ Are your contact details easy to locate?

2. **Formatting and presentation**
 ♦ Is it easy to read?

3. **Personal Profile (if included)**
 ♦ Does it add value?
 ♦ What would be lost by taking it out?

4. **Order of resume**
 ♦ Are the education and experience sections in the right order?

5. **Editing:**
 ♦ Is there anything that *doesn't* add value for an employer?
 ♦ Can it be expressed more succinctly?
 ♦ Is it up to date, reflecting you at your best?

6. **How could this document work better?**

Cover letter

Why should they hire you?

Use the cover letter to convince the employer of the ways that you can benefit them. Whilst your CV/resume provides evidence of your relevant experience, your cover letter is an opportunity to explain why your skills, experience and values make you a strong fit for the job.

Use the letter to outline what you are applying for and to sum up what you can offer the employer. Potential employers will use the letter to make an assessment of both your written communication skills and your interest in the job. A note that just reads 'as per your request, here is my CV' is a wasted opportunity. Invest time in writing one fully tailored, brilliantly researched and truly thoughtful cover letter. This is likely to be much more effective than sending off 20 impersonal, generic template letters.

Purpose

From your perspective, it needs to:

- convince the employer that you can benefit the company

- introduce yourself and to explain why you are a good fit for the position

- get you an interview, not the job itself.

From the employer's perspective, it needs to:

- weed out as many unsuitable candidates as possible by rejecting from the pile candidates who are inarticulate, pay little attention to detail or who have given insufficient thought to the specific role and what they can bring to it

- find out which candidates have a good understanding of what the role involves and its significance and have thoughtfully explained why they would contribute well to the company.

Research, Research, Research!

Just like the CV, you are not in a position to write a cover letter until you have undertaken considerable research, and have done everything you possibly can to get inside the head of the employer. You need to research the organisation, the Director and the role before you can begin to suggest how you share the company's mission, values and philosophy and satisfy their current needs.

Once again, internet and newspaper research, reading the company website and trade literature and talking to others are essential. Can you attend a talk or find an online video or newspaper interview with the Director or another member of the organisation, in which he or she talks about the organisation and its purpose? If so, this could really help you to understand the organisation's perception of itself, enabling you to subtly reflect back to them what they think and feel about themselves. There is simply too much competition for jobs to skip the vital research stage – and yet many people do.

Format

- Succinct – three or four short paragraphs, and usually not more than one page. (Letters for academic and museum curator jobs may be longer depending on your experience.)

- The layout and design should be inviting to the eye.

- The writing must be grammatically perfect.

Content

- Put your own name and address at the top of the page (usually centred or on the right).

- Put the address of the person to whom you are sending the letter ranged left, followed by the date.

- Address the letter formally. If you don't know the title to give the person, put their full name.

- Then put a heading with the title of the job you are applying for, and any reference number included in the advertisement.

- Start the letter by stating in the text which position you are applying for and express your interest in it.

- Briefly outline your relevant career history.

- Show why you are interested in this job, and avoid giving the impression that you're simply desperate for a job, any job!

- Demonstrate to the employer that you really understand not only what the organisation does but also why what they do is important.

- Show that you appreciate the achievements of which they are most proud.

- Show (positively) that you understand the areas that they are keen to develop.

- Show that you appreciate their current needs and can solve their problem. Explain what you will bring to the role and why you are a great fit. Use the letter to highlight relevant skills, experience, talents, interests, values, and qualifications that suggest you would have a strong aptitude for the job.

- Use two or three examples of relevant jobs or projects that you have undertaken to illustrate how and where you have developed particular, relevant skills.

- Sign off the letter 'Yours sincerely' (if you have addressed it to a named person) or 'Yours faithfully' (if it is addressed to Sir/Madam).

Tone

- Adopt a business-like tone that is also engaging, enthusiastic and warm.
- Consider the tone of the language used by the organisation and adopt a similar voice.
- Sound enthusiastic but keep it professional.
- Hone each sentence carefully so that every word counts.
- Never make the cardinal sin of misspelling the name of the organisation or the person to whom you are writing!

Personal statements

Many application forms require you to complete a personal statement in support of your application. You might be asked to give your reasons for applying, and other information relevant to the job specification, including your knowledge, skills and experience.

Your personal statement should relate directly to the specifications of the job or course you are applying for. It is important that you address all the points in the job specification. Imagine this being used as a checklist by the person short-listing.

You should use clearly themed paragraphs, maybe grouping together similar points on, for example, exhibition management, customer service, gallery events and administration within these themes. (To see how to break a job description into themes see the section on Interview preparation.)

Avoid simply repeating the words used in the job specification in your responses (e.g. 'I am committed to Equal Opportunities'). Make a personal interpretation of the criteria and quantify with clear examples.

If you are asked to provide a personal statement giving your 'reasons for applying for this post', you may choose to address this question in the introduction or the conclusion of your statement. Remember to couch this in terms of what attracted you to the organisation, rather than in terms of your need for a job! (See the section above on cover letters.)

Make sure your personal statement:

- shows that you have done your research on the company including its mission, values and key strengths
- uses language and phrasing that show enthusiasm for both the role and the company
- provides a brief summary of how your set of skills matches the post advertised.

Example of a Personal Statement

If the job description states 'commitment to promoting diversity and reaching out to potential visitors from diverse backgrounds' your paragraph might read in response:

Make a short statement summarising how you meet the requirement.	I am passionate about communicating art history to new audiences. I believe that it is essential to integrate diversity into everything the museum does, and to ensure that all aspects of the museum – the staff profile, the collections, audiences, programmes and events – reflect the diversity that exists within society.
Provide at least one concrete example of the assertion(s) you have just made.	Whilst working at the Serpentine gallery, I organised a series of events that were aimed at optimising awareness of our collection amongst students from black and Asian backgrounds. We held a series of events including debates, film and dance, inspired by our exhibition on Chris Offili. Chris was invited to chair an art mentoring day for aspiring young black artists. I also helped organise art sessions with prisoners, which culminated in an exhibition I curated.
Reflect and add depth to the point you're making.	Both experiences were extremely rewarding and have given me a sensitivity to the need to be inclusive of the cultures and circumstances of others.

General points

Be positive

When writing in the first person on application forms, be positive and affirmative. Avoid saying: 'I feel that I am a good communicator', or: 'I believe in diversity and equal opportunities.' Say rather: 'I am a good communicator', and: 'I am committed to diversity and equal opportunities.' Do not invite the employer to question the strength of your skills.

Sending applications via email

♦ Always write a short but *formal* note in the body of the email. Never make the mistake of thinking you can be casual just because it is an email.

♦ If you have the facility, it is best to save your CV as a pdf file, to ensure that the formatting will remain unchanged when opened on another computer system.

Online recruitment forms

These have become increasingly common over the years and have proved advantageous to both recruiters and applicants. A good, tailored online application requires the same advance preparation as a targeted CV or a hard copy form, but may be harder to check.

♦ Revise and edit your text so that it is clear, precise and convincing.

♦ Plan your answers in a Word document (or similar) where you will also be able to spell-check it, before copying and pasting the finished version into the form.

♦ Make time to check it through and ensure it is effectively targeted to the position and employer. Formality of tone is a must.

♦ When you think you have completed the form, ask someone to check it.

♦ Keep a copy of your application and job advertisement details in case you need them for interview preparation.

Informational interviews

Informational interviews are an effective way to build your network and learn a lot more about an employer and the field. Contact employers you are interested in to request a 20–30 minute informational interview. If possible, arrange the meeting through a mutual contact. Whereas an employer might well turn down a request for a job interview, they are often flattered and say yes when asked for their advice or opinion.

Most arts jobs are found through referral networks, so in addition to attending openings and other industry events, informational interviews are a good way to get connected. Meeting new people and going to informational interviews will not only give you a solid

Power words

Recruiters have to trawl through many applications, including some that seem indistinguishable and unremarkable. Help them to find what they want by using direct, positive and appropriate language in your application. Know your audience.

These words and phrases may be useful in job applications:

Experience
Demonstrated skills in...
Extensive academic/practical background in...
Experienced in all aspects of...
Knowledge of/experienced as/proficient in...
Provided technical assistance to...

Ability
Trained in...
Proficient in/competent at...
Initially employed to...
Expert at...
Working knowledge of...
Coordinated...
Organised...

Success
Promoted to...
Succeeded in...
Proven track record in...
Experience involved/included...
Successful in/at...
Instrumental in...
Delivered...

Responsibilities
In charge of...
Supervised/delegated...
Now involved in/coordinate...
Familiar with...
Employed to/handle...
Assigned to...
Project managed...

Roles
Analysed/evaluated...
Established/created/designed...
Formulated...
Initiated...
Orchestrated...
Managed...
Presented...

Personal attributes
Committed to...
Confident
Enthusiastic user of...
Thorough...
Actively sought...

knowledge and understanding of your field but will also help you to make a strategic decision about your future.

Prepare a list of questions

Do not ask questions that are routine and for which answers are readily available, but undertake research into the company and career before the meeting so that you can find something that furthers the conversation:

- What are the challenges facing the sector at the moment?
- Is there a typical career route into this area?
- How did you get into the industry?
- What associations and trade publications best represent this industry?
- What additional qualifications and experience do I need to enter this field?
- See further information on website with ideas for questions.

Be prepared to answer questions about yourself and the role in case it should turn into a spur-of-the-moment job interview. If you phone to request the interview, make sure that you have your questions ready, as your only option may be to hold an informational meeting over the telephone then and there!

Job interviews

Congratulations on getting an interview! If you have got to this stage, you can feel reassured that the employers appreciate that you have the skills and ability to do the job. Having already convinced them of this in your CV and cover letter you now need to show that you are the best fit for the role.

Purpose

From your perspective, you want to:

- get a job offer
- get information about the role and the company and your potential boss
- be in a position to make a sound decision as to whether or not you want the job.

From their perspective, they want to:

- check you have the ability to do the job
- see how much you want the job. Are you motivated, excited and enthusiastic?
- see if you are a good fit for the company
- see what added value you will bring to the company.

Remember that you are not just going to be interviewed, you are also interviewing them. An ideal interview situation involves give and take, with both sides asking and answering questions.

Preparing for the interview

Once again but now in further depth, research:

- the organisation
- the role
- yourself.

Researching the organisation

In an ideal world you should undertake sufficient research that you go into the interview knowing almost as much about the company as a recent employee might. It is vital that you understand how the company perceives itself. What are its unique strengths, limitations and future plans? It is inexcusable not to be informed when some simple internet research can provide abundant information.

A favourite question asked at interview is, "Why are you interested in our organisation?" If you don't know anything about the employer, you won't be able to answer the question intelligently. Employers will not take you seriously unless you can demonstrate reasonable knowledge of the company. They will be impressed if you are familiar with what the organisation does and with its values and ethos.

Researching the organisation also helps you to determine whether you are a good fit for the company in terms of your own values and personal outlook on life and whether working there will enable you to meet your goals. Once again, pull out all the stops with your research!

See overleaf for help in structuring this research.

Spend further time brainstorming the role.

- How were things done in the past?
- How are they done at other organisations?
- What opportunities are there for developing the role and organisation?
- What new knowledge and experience can you bring to the post?

Think more deeply about the role. What other skills and qualities will it require for you to make a success of it, and what evidence can you offer that you have these?

Researching yourself

Spending some time thinking about which values are most important to you and how these relate to your career choices can be a useful process. Understanding what

Facts to find out about an organisation	
Size (number of employees and turnover)	*Unique characteristics*
What do they do/sell?	*Potential new products or services*
What services do they offer?	*Competition or threats*
Potential growth areas	*Annual sales growth for past five years – e.g. for auctions*
Geographical locations	*Location of corporate headquarters, offices, galleries, sales rooms etc.*
Organisational structure	*Age of top management and their backgrounds*
Type of training program	*Promotional path*
Recent developments via news stories	*History of organisation*
Who will be interviewing you? (Names, their interests and roles and responsibilities within the organisation.)	

makes you tick will help you to decide whether a job is right for you. It can also help you to convey to the employer why you are right for the role.

For example do you like helping other people overcome problems or helping with their personal development? Are you creative? Do you like work that is meaningful? Do you like selling? Do you like teamwork or working alone? Are you research driven?

Know your product
The interview is about selling – selling your talents, skills, time, energy and commitment

In order to do this you need to be able to recognise and prioritise your strengths. Like any good salesperson you need plenty of product knowledge. Take a good hard look at all of your vast pool of talent and ability.

Create your own "Strengths Shield"

To help firm up your product knowledge, create a Strengths Shield to boost your awareness of your talents, and hence your self-confidence. The shield will act as your armour or forcefield as you work your way through the art job market.

Hard Skills

Qualifications and skills
For example: driving, computer programmes, languages, installation work, cataloguing skills, photography, copyright law etc.

Don't compare your ability level with that of others or be humble or modest. If you can do it, write it down. Think marketing!

Soft Skills

Behaviour and Interpersonal skills
For example: Communicating, handling customers, giving advice, being assertive, teambuilding, persuading, selling, negotiating, attention to detail, mentoring, leadership, time management, organisation, motivational, handling difficult people etc.

Achievements

What have you done in your life that took effort and resolve? What are you most proud of? What personal challenge have you overcome? What projects have you set yourself?
For example: Raised £3000 for a charity; led a team of five on a £2 million project; cared for someone; ran a marathon; built a house; set up an exhibition; learnt to teach English as a foreign language; passed the driving test, won an academic prize etc.

Personality

Positive words that define you or describe your personality. What personality plus points would you bring to the new job?
For example: analytical, thoughtful, confident, hard working, assertive, flexible, discrete, focused, self- motivated, enthusiastic, trustworthy, positive etc.

The core job of the shield is to give you a boost so that you glow with confidence in the meeting, but it will also help you brainstorm key points to raise at interview.

For each job that you go for you can lay the strengths shield out in front of you and select the skills, qualifications and competencies that are most relevant for the job you are applying for.

Use it to help you practise articulating your key strengths in a confident and comfortable manner. Here is an example of how it works:

Let's imagine that you are straight out of university, with little previous work experience and are applying for a job as administrative assistant in the Jewellery and Valuations department of an auction house (see below).

What are your key strengths for the role?

How easy or hard did you find it to think of good examples to demonstrate your ability for each area? If you found it almost impossible, then perhaps the role is not the right one for you.

Having examined the role in detail and built your Strengths Shield, you should be able to identify the key strengths that you could bring to the company. Your priority in the interview will be to articulate these key strengths and support them with quantifiable accomplishments in such a way that they are remembered and believed. Reflect on past jobs and prepare five or more success stories that incorporate these strengths.

1 Refer to the Job Specification

Job Information

Job Title	Administrative Assistant – Jewellery and Valuations
Job Description	Auction Atrium is currently seeking to recruit an administrative assistant to the Head of Business Development. The role will include client liaison and assistance with cataloguing our monthly Kensington and Jewellery sales. Some prior knowledge and interest in the Fine Arts is essential and candidates must have a thorough knowledge of practical IT skills and be able to work as part of a team.
Type of Job	Full time
Job Location	London

Company Information

Company Name	Auction Atrium
Company Description	Auction Atrium is a London-based auction house that sells fine art, antiques and collectables online. We aim to combine the integrity, expertise and customer care of the established auction houses with the dynamism, low transaction costs and versatility of the internet.
Application Instructions	To apply for this position please email your CV a.s.a.p. with a brief covering letter to Joe Bloggs JoeBloggs@auctionx.com

2 Identify keywords	3 Group the keywords into themes	
assistant to head	**Administrative**	**Appreciation of the unique nature of the company**
business development	IT skills	low transaction costs
jewellery		dynamism
valuations	**Ability to work with others**	Business Development
IT skills	teamwork	versatility of the internet
client liaison	customer care	
knowledge in the fine arts	client liaison	**Art**
teamwork	Assistant to Head	knowledge and interest in the fine arts, antiques and collectables
auction house		expertise
sells online		cataloguing
fine art, antiques and collectables		jewellery
integrity		valuations
expertise		
customer care		
dynamism		

Sell your weak points

For which of the points on the job description did you struggle to think of an example that would sell your capabilities?

It is important to identify the areas that employers might consider to be your weak points as a candidate for the job. Think about how you might convince the employer that in fact you are not weak in this area, despite appearances.

For example, if the job asks for good client relationship skills but you have never worked in a customer-facing role, you might describe how you gained excellent people skills as the president of a society whilst at university, and go on to explain how you solved members' problems.

The employer will be thinking:

- How mentally alert and responsive is the job candidate?

- Is the applicant able to draw proper inferences and conclusions during the interview?

- Does the applicant demonstrate a degree of intellectual depth when communicating, or is his/her thinking shallow and lacking depth?

- Has the candidate used good judgment and common sense regarding life planning?

- What is the applicant's capacity for problem-solving activities?

- How well does the candidate respond to stress and pressure?

You can prepare by thinking about how you will demonstrate these qualities and abilities through your body language and the things you say.

Mental attitude

You need to believe that you can do the job.

- An interview ought to be challenging, stimulating and only mildly daunting.

- The interviewer wants you to be brilliant – thus solving their problem.

- Don't scupper your chances with negative thinking.

- Be yourself, at your very best.

- This doesn't mean sit back and hope they like you. You must be polished and prepared!

Practised, Polished and Prepared

A job-seeker going to an interview without preparing is like an actor performing on the opening night without rehearsing. Before stepping into an interview, be sure to practise, practise, practise!

- Draw up a list of questions you think might be asked by using your research into the company, asking other professionals in the field what they would ask, or searching for relevant questions on Google (e.g. search 'Interview Questions Development Officer'). The questions should probe your capability in all the key themed areas you identified on the job description.

- Role-play the questions and answers with friends and family. Ask for feedback on how well you listened, responded, and presented yourself.

- Search Google images to see if you can find photographs of your interviewers. Cut and paste them onto a Word document and practise answering your questions to your pictures of their faces. This will help you to be more confident when you meet them in the flesh!

- Practise seated in front of a mirror (or even video yourself) so that you can observe your body language. Are you smiling enough and making eye contact? Do you have any nervous ticks?!

Presentation

- Take your time to consider the appropriate. professional dress code for each interview.

- Avoid wearing too much perfume/aftershave or makeup.

- Remember, throughout the interview the interviewer will be assessing you to determine if you would be a good representative for their company.

- Be on time! Arriving late creates a very bad impression. If you are running late because of an emergency, you should phone ahead. Arrive at least 15 minutes early so that you can compose yourself for the upcoming interview. Give yourself extra time to find the interview location if you are visiting an area that you are unfamiliar with.

What structure will the interview take?

Most interviews tend to fit a general pattern and share three common characteristics: the beginning, middle and conclusion. The typical interview for an entry-level position will last 30 minutes, although some may be longer. A typical structure is as follows:

- 5 minutes of small talk

- 15 minutes discussing your background and credentials as they relate to the employer's needs

- 5-minute opportunity for you to ask any questions you might have

- 5 minutes to wrap up the interview.

How's your small talk?

Many recruiters will begin the interview with some small talk. Topics may range from the weather, your journey or some topical event in the news that day. You must do more than just smile and nod. Make sure that your comments are upbeat. If your train was delayed or the weather was bad, make sure that you are not seen to moan or appear stressed.

The recruiter takes the floor

The main part of the interview starts when the recruiter begins discussing the organisation. Ask questions at this point if you need more information about the role.

Be an active listener

♦ Be responsive.

♦ Listen carefully. Thinking ahead for your answers rather than listening leads to lack of attention, but also self-consciousness and anxiety.

♦ Nod, smile, let them know you agree with what they are saying.

What might they ask?

The discussion will then turn to your qualifications and suitability for the role. Always take a few copies of your resume with you to the interview – you can refer to this if you need inspiration to help you answer a question, or if you need to check a fact such as how long you worked at an organisation for.

♦ Ask for clarification if you don't understand a question or their reason for asking it.

♦ Be prepared to answer questions that deal with your weak points (see above).

♦ Give well developed but not overly long answers. Limit your answers to two or three minutes per question, unless asked to give more detail. Time yourself and see how long it takes you to fully answer a question.

Be prepared to answer requests for information such as:

1 *Tell me about yourself.*
 Prepare a short statement about yourself selling your best features. Then add "There's so much I can tell you, but I want to focus on what's important to you. What specifically would you like to know about?" This allows you to find out more about what they value and enables you to answer a narrower question.

2 *Tell us what you know about us.*
 This is your chance to demonstrate that you have done your research and read their literature and understand what is important to them. Mention some

of their recent successes and demonstrate awareness of any key new areas that they are moving into. Always be prepared to talk about recent events at the organisation such as exhibitions, lectures or auction results. If it is a public-facing organisation, such as a gallery, they would expect you to have visited previously.

3 *Why do you want to work for us?*
 Respond to this question rather than answering it. So, instead of setting out how the job will fulfil your career aspirations, let them know why you will enjoy contributing to their organisation.

4 *What experience do you have?*
 Focus on relevant experience in the area as well as transferable skills. Relate your experiences to the tasks described on the job description, and demonstrate that you have the skills and attributes listed in the person specification.

5 *What are you looking for in this job?*
 Focus your reply on what you will do for them. For example, rather than saying "I am looking to develop my knowledge of contemporary art" (which will sound to them as if you are weak in contemporary art) say that you are looking for an opportunity to really use your knowledge and expertise in contemporary art and to share your passion with new audiences.

6 *Why should we hire you?*

7 *What are your greatest strengths and weaknesses?*
 Sell your success factors that relate specifically to the job and give examples of how you have applied those qualities. When mentioning a mild weakness, couple it with a positive attribute and show that you are working on the weakness. For example, "My attention to detail means that I sometimes work very close to the deadlines. I am working on this by becoming more organised, and allowing myself more time so that I can continue to do a great job." Then ask "What do you think are the most important strengths needed for this job?"

8 *Where do you see yourself in 5 to 10 years time?*

9 *I'm not sure that you have the experience or training to handle this job. Do you?*

10 *I see you were previously a lawyer. That sounds very exciting. Why would you want to give up that position for a job in our auction house? The pay will never be as good!*

Offer 'features' followed by 'benefits'

Employer: This is a very busy gallery with lots of customers. I need someone who can keep track of all our clients. Can you do that?

You: I'm very organized. (*Feature*) In my last job I created a database system that recorded all our clients' names and contact details, what they had bought and when, which staff member they knew best, and any other network connections, as well as personal information they might have mentioned, such as if a grandchild had just been born. That way when they next came into the gallery we could always carry on the conversation without relying on memory. This made our customers feel that we valued them highly and ensured that they kept returning and spent with us. (*Benefit*).

Respond to the question (Don't necessarily answer it directly).

Employer: Have you ever worked in a commercial gallery before?

You: I have curatorial experience in a public gallery and also have great sales and customer service experience at Harrods so I'm confident that I have the best possible training and experience in both sales and gallery management. In my last job I was transferred into a new division of the company and my supervisors were very pleased with how quickly I learned and adapted my skills.

Behavioural questions and the STAR Method

You may be asked to give examples to illustrate your skills and achievements. For example:

Tell me about a time when you …

♦ worked as a team

♦ managed a project

♦ convinced someone to see things your way

♦ used good judgment and logic to solve a problem

♦ adapted to change

♦ set an important goal, and reached it.

Your ability to clearly and concisely respond to such questions in an informed manner that relates your background to the question posed will set you apart. The STAR method simply provides a logical approach to answering any question by providing a guided approach to using one of your past successes in responding to the question.

S = Situation Describe the general situation. When and where?

T = Task What was the problem that you faced?

A = Action What action did you personally take?

R = Result What was the result of your action? How did the event end? What did you accomplish? What did you learn? Quantify where possible. How much money did you save? How many paintings did you sell? How many VIPs did you persuade to come to the event? Be sure to include concrete, quantifiable data and avoid talking in generalities.

Although this may seem an awkward way of talking at first, it's worth practising. It will help you stay focused in the interview, stop you from waffling, and ensure that you remember to explain the problem and your role and accomplishments in detail, using measurable information. It also ensures that you end on a positive note – i.e. the successful outcome.

> **Situation:** During my 3-month internship at the Peggy Guggenheim last summer, I was responsible for managing the free lunchtime lecture series.
>
> **Task:** I learnt that whilst the attendance of foreign visitors was high, the attendance at lunchtime lectures by local city workers had dropped by 30% over the past 3 years and I wanted to do something to improve these numbers and get the community more engaged with the gallery.
>
> **Action:** So I decided to design a new promotional packet to go out to the local community businesses to attract local workers to come into the gallery during their lunch breaks. I also included a rating sheet to collect feedback on our events, and organised an internal round table discussion to raise awareness of the issue with our employees.
>
> **Result:** Two recurring suggestions from the community were to change the times to allow workers to get back to their offices promptly and to allow people to bring in sandwiches to eat during the lecture. By making these simple changes in conjunction with renewed marketing, I was able to raise attendance by 18% that summer. Two of the new regulars at the galleries have become major donors and we also picked up 10 new volunteers, with many of the attendees signing up to take part on some of our short courses, bringing valuable income to the gallery.

Do you have any questions for us?

The interview process is a two-way street whereby you and the interviewer assess each other to determine if there is an appropriate match. You need to ask questions in order to learn about the job. Asking questions also enables you to take control and steer the course of the interview.

- Ask questions at any stage of the interview, and be sure to have something to ask at the end.

- It's okay to bring out a list in the interview. This shows the employer that you are serious about the organisation and need more information.

- Ask questions that will elicit positive responses from the employer

The types of questions you ask and the way you ask them can make a tremendous impression on the interviewer.

Plan your questions to them

Prepare intelligent thoughtful questions that bring out your interest in and knowledge of the organisation, and which demonstrate that you have thought seriously about the job/company and done your homework on them. Your questions should demonstrate that you are an active, energetic, confident and intellectually curious person that takes initiative and that you are really interested and enthusiastic about the job.

Thoughtful, company-specific questions that arose during your research are best. However, you can often incorporate company specific information into stock questions. For example, interviewees often ask "What are the major issues that the company is facing at the moment?" However, since you want to show that you are knowledgeable about the company, you might ask instead: I am aware that in London, Sotheby's closed its low-end, Olympia sale room in 2007 in order to concentrate, very successfully, on the high-end market. Are there any other major changes to the organisation in the pipeline?

Some stock questions include:

- What would you expect me to achieve in the first 6 months?

- Where is the company going? Upwards? Expansion plans?

- Who would I report to? Where does he/she fit in the structure?

- Who are your customers?

- What training do you provide?

Maintain a conversational flow

By consciously maintaining a conversational flow, a dialogue instead of a monologue, you will be perceived more positively.

Use feedback questions at the end of your answers and use body language and voice intonation to create a conversational interchange between you and the interviewer.

The close of the interview

The interview is not over until you walk out of the door. The conclusion usually lasts five minutes and is very important. During this time the recruiter is assessing your overall performance.

It is important to remain enthusiastic and courteous. Often, the conclusion of the interview is indicated when the recruiter stands up. However, if you feel the interview has reached its conclusion, feel free to stand up first. Shake the recruiter's hand and thank him or her for considering you. Being forthright is a quality that most employers will respect, indicating that you feel you have presented your case and the decision is now up to the employer.

Follow up

Always follow up your interview or information session with a prospective employer with a brief thank you note. A simple, hand-written note or business letter with appropriate stationery will keep you in the employer's mind and possibly make you stand out among other candidates. Start your letter by thanking him/her for taking the time to interview you. Follow by concisely restating your skills and what you can offer the company and any additional thoughts that have come to you on reflection following the interview. (If there is anything you wish you had answered differently or expanded further on, now is your chance to put this right.) End the letter by emphasising your interest in the position and state that you are looking forward to hearing from him/her again.

Salary

- You should not bring up salary in your first interview.

- Instead, spend your time discussing the position and focus on what you can bring to the role and how you will add value to the company.

- Go online and familiarise yourself with the standard salary for your field.

- When you are actually offered a job, negotiate your salary and benefits.

- Keep in mind starting salaries are generally low in the arts (often £14,000–£22,000 for a first position), so you may need to spend your first few serious arts jobs gathering experience and developing networks prior to being paid what you feel you are worth.

Review your performance

If you are unsuccessful, try not to take it as a personal rejection. It simply means that they felt that another candidate was a better fit for the organisation and that role in particular, on this occasion.

Always seek feedback

If you feel that you have put in a good application for a job and have not been short-listed, seek feedback by sending a short pleasant email asking how you might improve for the future. This is not always forthcoming, but may help you find out exactly why your application failed. This may indicate something that you can easily improve, or provide useful tips for future applications.

It is often difficult to hear constructive criticism, but remember not to react in a negative manner. Say thank you to whoever gives you feedback and remember that whatever you are told can be put to good use.

Interview journal

As soon as possible, write a brief summary of what happened. Keep a journal of your attitude and the way you answered the questions. Did you ask questions to get the information you needed? Did any of the questions surprise you? What might you do differently next time?

Final word

This may all seem like a lot of trouble to go to. However, finding the right job is hard work in today's economic climate, and approaching it seriously will help to stack the odds in your favour. There is keen competition for every post and it is essential that you market yourself successfully.

You only get one chance to leave the right impression, so take the time to do your homework and research the organisation, and you will increase your chances of leaving a positive impression.

FURTHER INFORMATION

Useful websites

Standard job descriptions:
www.prospects.ac.uk

200 Informational Interview questions:
www.quintcareers.com/informational_interview_questions.html

Books

There are numerous books available on CV/resume and cover-letter writing, and on interview preparation. Some will reinforce what is written above; others will supplement or maybe even contradict it. There is no single 'right' way of applying for a job. Ultimately, you will have to find your own path.

Internships & Voluntary Work

Matt Lodder

Association of Art Historians

Internships and periods of voluntary work remain a common route into a career in the arts industries, including galleries, auction houses, museums, heritage organisations, and art dealers. An internship can provide valuable work experience for individuals looking to gain skills and connections in order to boost their employability after their studies have been completed, but it is important to note that they are often unpaid, and competitive, where offered. Internships do confer a competitive edge to individuals if and when permanent, paid positions become available at the institutions at which they have volunteered, however, so they will often pay off in the long run.

Several larger organisations regularly offer fixed-term internships, which are advertised on their websites in the same way as ordinary job vacancies (see below). These advertised internships will often be focused on a specific project or department (such as education, marketing, collections, etc.) and will usually offer expenses and a small *per diem* rate. Otherwise, individuals seeking voluntary work experience are encouraged to contact potential host institutions directly. It is recommended that initial, informal, speculative enquiries are made by email or by telephone to see if internship applications are welcome, and to introduce yourself and your particular skill-set, which can then be followed up with a formal CV if requested.

AAH Internship Awards

The AAH offers funding to UK-based undergraduate and postgraduate students on placements or internships. There are two awards of up to £2,000 towards placement-related expenses such as accommodation, travel and food. The AAH Internship Award supports both full-time and part-time placements/internships. Recent awardees have worked in such diverse institutions as The Landmark Trust, Modern Art Oxford, White Cube, and The Art Loss Register, and applicants can apply for placements in the wider art world both in the UK and abroad. (Please note, the award is open to current AAH members only).

FURTHER INFORMATION

Internships

Many of the larger institutions offer internships. This is just a selection:

Tate www.tate.org.uk

V&A Conservation Department www.vam.ac.uk/

Cell Project Space http://www.cellprojects.org/internship

The Hayward www.southbankcentre.co.uk

Barber Institute of Fine Arts http://barber.org.uk

AAH Internship Awards

Further details under Funding on AAH website: www.aah.org.uk

You will need to be an AAH member to apply, but this is just one of the many opportunities that will open up to you as a result of joining.

Made in the USA
Monee, IL
09 January 2024

51483351R00055